Saunière's model
and the Secret
of Rennes-le-Château

Frontier Publishing

Adventures Unlimited Press

Saunière's model and the Secret of Rennes-le-Château

*The priest's final legacy
that unveils the location
of his terrifying discovery*

André Douzet

Translated by Gay Roberts and Philip Coppens
Edited by Philip Coppens

Adventures Unlimited Press
Frontier Publishing

© André Douzet 2001&2004
ISBN 0-932813-50-X

for more information, see www.perillos.com

Frontier Publishing
PO Box 48
1600 AA Enkhuizen
the Netherlands
e-mail: fp@fsf.nl
http://www..fsf.nl

Table of Contents

Introduction

Rennes-le-Château. Many works and theses have been written on this fascinating village. Layer upon layer of theories have been put forward. But at the core of each is the following, simple starting point: Abbé Saunière, the enigmatic priest, must have made a discovery one century ago, either intentionally or otherwise. It would change the course of his life. But what was the nature of the discovery? Was it a treasure of a monetary nature? Or was the treasure purely spiritual? Was it an archive, or untold secrets, perhaps a historical, religious or archaeological revelation? What was the method that allowed him to unravel this wonderful enigma?

Political, religious, literary, artistic, cultural and aristocratic personalities were all players in this fantastic fresco, sometimes comical, sometimes theatrical, sometimes dramatic, but also, alas, tragic...

But, above all, must be the realisation that faced with such an abundance of literature, it is astonishing that in practice, nothing tangible has ever been found.

Many trails have been followed. Certainly numerous ones were suggested to me. Practically all of them have ended up as dead ends or transformed themselves into quests that can never been fulfilled. All this has been linked to hypotheses, appearing in many guises: scientific or fantasy, historical or raving mad, rational or empirical.

Rennes-le-Château seems to have resigned itself to the status of a "perpetual mystery", where layer upon layer of rumour, innuendo, half-truths, utter fabrications, fantasies and much more mix into a grotesque labyrinth that no-one is able to negotiate... or even enter. What can one make of a simple, French, village priest, who had nevertheless several bank accounts, including one as far away as Budapest?

So has everything been said? And should we desist from further research? In 1992, I decided to reveal, to a small group of people intimately familiar with the mystery, the existence of a model, ordered by Saunière before his death, but never collected from the factory in Lyons. At the same time, I showed documents showing that Saunière had been to Lyons. Three years later, I felt the time was ripe to make my discovery known to the general public. On July 29, 1995, a press conference with the first public display of the model was held at Saunière's estate, then and now a museum. Over the past eight years, many pieces of the puzzle have

fallen into place, and this book is the first time all these and preceding details regarding this discovery — in its varying aspects — is published. Finally, it will unveil the location of the real mystery of Rennes-le-Château.

Part I

Painting the scenery
of Rennes-le-Château

Chapter 1
Many roads leading into one mystery

At the end of the 19th and the beginning of the 20th Century, a small village priest in the South of France displayed wealth that exceeded his income. Bérenger Saunière had been appointed the village priest of Rennes-le-Château on June 1, 1885, heading a congregation of two hundred people. Rather than being the archetype of the reclusive village priest, Saunière led an exuberant life-style, to which he coupled an eccentric taste in church decoration... or, as many believe, he used his church's interior as a puzzle to piece together the answer of the source of his anomalous income.

It is assumed that the mystery of the priest's wealth began when he made vital repairs to his village church in 1891, to safeguard the physical well-being of all those attending mass. It is said that during those repairs, he stumbled upon certain parchments hidden inside the church. Whatever the nature of the document, it is believed that it contained the key to the source of the priest's wealth.

After informing his bishop, Mgr. Billard, he also apparently received his sponsorship and protection. When the hands at the helm of the office changed to Mgr. de Beauséjour, now the bishop of Carcassonne, so did the fortune of Bérenger Saunière. Together with his "maid", Marie Denarnaud, Saunière decided to ignore the orders of his new superior, and he continued to do so until the end of his days, in 1917. Ordered to move to the village of Coustouge to become parish priest there, Saunière refused, claiming the location was too close to Durban/Corbières and its Carthusian monks. There are no such monks there.

On January 22, 1917, Saunière died as the result of a stroke suffered some days before. For the next forty years, Marie Denarnaud would remain the living reminder of the wealth of Saunière, staying in the house he built for them both, situated next to the village church of Rennes-le-Château. She remained there until the early 1950s, when the first phase to promote and exploit the life of Saunière was made by entrepreneur Noel Corbu, who had bought the priest's estate, turning it into a restaurant. Some decades later, it would become both a hotel and a museum, attracting visitors from all corners of the world. Today, this quiet village boasts a special parking place for buses, shuttling the tourists to this remote area from where the distant peaks of the Pyrenean mountains can be seen.

The story of Rennes-le-Château and its enigmatic priest was promoted

in the 1960s and 1970s by the French author and journalist Gérard de Sède. It led to several imitations, expansions, and the usual twists in the plot, both in France and elsewhere. After the publication of *Holy Blood, Holy Grail*, by three English authors, Michael Baigent, Richard Leigh and Henry Lincoln, in 1982, the enigma became established as an internationally renowned mystery, linked with theories of Jesus surviving the crucifixion and Mary Magdalene being his lover, wife, and mother of his children. At the same time, certain groups tried to tilt the story and turn it to their profit.

During all of these different stages and phases of the mystery surrounding this village priest, some aspects of the mystery have remained at the basic core of the story. All of these need to be briefly discussed.

A. The Parchments

The parchments were discovered during Saunière's essential repair works in the church. This fact is undeniable, as there were witnesses present. In the words of Baigent, Leigh and Lincoln in *The Holy Blood and the Holy Grail*: "Saunière embarked on a modest restoration, borrowing a small sum from the village funds. In the course of his endeavours he removed the altar-stone, which rested on two archaic Visigothic columns. One of these columns proved to be hollow. Inside, the curé found four parchments preserved in sealed wooden tubes." The two workmen, Piboleu and Babou, were discharged from their job and it is said that Saunière carried on the researches himself.

But what did Bérenger Saunière do with the parchments? Gérard de Sède claims to have obtained a copy of them, but there is nothing to guarantee those documents' authenticity. De Sède also claims to have submitted them to coding experts but does not let us have the message they are supposed to contain.

It was only in October 1973, in a French magazine called *Pegasus*, issue 5, that the former Belgian television producer Philippe de Chérisey offered a decipherment that would be copied by all subsequent authors as the authoritative decipherment of the parchments:

Bergere, pas de tentation. Que Poussin, Teniers gardent le clef. Pax DCLXXXI. Par la Croix et ce cheval de Dieu, j'acheve ce daemon de gardien a midi. Pommes bleues.

Shepherdess, no temptation. That Poussin, Teniers hold the key. Pax

> ETFACTUMESTCUMIN
> SABBATOSECUNDOPRIMOA
> BIREPERSCCETESAISGIPULIAUTEMILLTRISCOE
> PERUNTVELLERESPICASETFRICANTESMANTBVS + MANDU
> CABANTQUIDAMAUTEMDEFARISAEISDT
> CEBANTELECCEQUIAFACIUNTDISCIPULITVISAB
> BATIS + QUODHONLICGTRESPONDENSAUTEMINS
> SETXTTADEOSNUMQUAMBBC
> LECISTISQUODFECITDAUTDQUANDO
> ESURUTIPSEETQUICUMEOERAI + INTROIBITINDUMUO
> dEIETPANESPROPOSITIONIS REDIS
> MANDUCAUITETdEdITETQUI BIES
> CUMERANTUXUO QUIBUSNO
> NLICEDATMANDUCARESINON SOLIS SACERDOTIBUS

DCLXXXI [Latin: Peace 1681]. By the Cross and this horse of God, I achieve this demon of the guardian at noon. Blue apples.

In 1978, Franck Marie published *Rennes-le-Château—a critical study*. According to his account, he arrived at an identical decipherment and message. The enigmatic text was interpreted as referring to the works of the painter Nicolas Poussin, i.e. *The Shepherds of Arcadia*, David Teniers, i.e. *The Temptation of St Anthony*, and Eugène Delacroix, i.e. *Heliodore being chased from the Temple*. Bérenger Saunière had apparently brought back reproductions from the first two paintings from a trip to Paris and had admired the third at length in the Parisian church of St Sulpice, where it can be seen to this very day.

But some time after the publication of his article in *Pegasus*, de Chérisey confessed that he himself had created the documents, admitting they were therefore forgeries – and thus making the "hidden message" of no importance. Knowing that the municipal archives of Rennes-le-Château had disappeared, he had fabricated all the items from a parchment available in the Bibliotheque Nationale in Paris. De Chérisey stated it was he who had slipped the copies to de Sède, who, without doubt, was manipulated in this affair by a group of people, among whom was a certain Pierre Plantard, a name that had cropped up in de Sède's previous book, *Les Templiers sont parmi nous* (The Templars Are Among Us). The book was the first of a trilogy that would end with *La Race Fabuleuse* (The Fabulous Race), which tackled not only the subject of Rennes-le-Château,

7

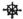

JESVSEVRGOaNTCCSEXdTPESPaSCShaEVENJTTbEThqaNTaMVRaT
JVEKaOTIaZa▪VVSMORTYVVSqVEMMSVSCTYTaVITIYESVSFEdCERVNT
.LaVIEM▪TTCaENaPMTbTETOMaRThahMINISTRRabaTlbaSaRVSO
VEROVNXVSERaTTE×dTSCOVMlENTdTLVSCVJMMaRTaLERGOaChCEP
TllKThRaMYNNGENTTJNaRaTPFTSTTCTqPKETTOVSTETVNEXTTPE
dPESTERVaETEXTEJRSTTCaYPTIRTSNSVTSPEPdESERTPTETdOMbESTM
PLFTTaESTEEXVNGEINTTOdaEREdIXaITERGOVRNVMEXdGTSCTPVhL
TSETVTXTVdaXjSCaRJORTTSqVIYERaTCVhMTRadTTTYRYSqTVaREhOCCVN
ѣENVTVMNONXVENVͤTTGRECENPdTSdENaaRͦVSETddaTVMESGTE
GENTEͤS?dIXTNVFEMhOͤCNONqVSTadECGaENTSPERRTINEbEaT
adCVTMSEdqVhInFVRElKTSTlOVCVlOShCabENSECaqVaEMVTTIEba
NMTVKPOTRabETEdTXTTEJKGOTEShVSSTNEPTlLaMVNTTXdIERMS
EPVlGTVKaEMSEaESERVNETIllqVdPaVPJERESENhTMSEMPGERha
bEMTTSNObLTTSCVMFMEaVTETMNONSESMPERhaVbEMSCJOGNO
VILTEKOTZVRbaMVqlTaEXTMVdaCTSTqVTaTlOlTCESTXETYENE
aRVNTNONNPROTEPRTESVᵐETaNTᵛᵐMSEdVTLVZaRͦVMPVTdER
ChⵜTqVEMKSVSCTaOVTTaMORRTVTSCPOGTTaVKERVNTahVTEMP
RVTNCTPEJSSaCERCdOTVMVMTETLaZCaRVMTNaTERFTCTRRENTY
LVTaMYLVTTPROPqTERILhXVMahTbGNTCXVGTaaETSNETCRCd
dEbaNTTHTNTESVM

NⵙⵜIS

JÉSV. MEdÉLa. VULNÉRVM ✠ SPES. VNa. PŒNITENTIVM.
PER. MaGdaLaNÆ. LaCHRYMaS ✠ PECCaTa. NOSTRa. dILVaS.

the possible survival of the Knights Templar following their dissolution
by the Pope in 14th Century, and the possible location of their treasure,
but also extra-terrestrial visitors from the star Sirius.

B. Visiting Paris

The story goes that upon Saunière's discovery of the parchments, he went to his bishop, Mgr. Billard, in Carcassonne and showed him the parchments. What would normally happen in any bishopric? The documents would probably follow a hierarchical chain and the priest would return home, empty-handed. But in the tale of Rennes-le-Château, the priest allegedly departed on a mission to Paris with introductions to open certain people's doors and money for travelling expenses. In the capital, our poor priest from a deserted corner at the very bottom of France is admitted into society's upper crust. He allegedly attends various "high society do's" and becomes the lover of a famous singer, Emma Calvé, at the height of her career and fame. But unfortunately for those advocating this story as the truth, there is no proof for these allegations. And if the village priest and the opera star were lovers, it is clear that Saunière soon returned to his home in the South of France, without his love. Only Gérard de Sède claims to possess a photo of Bérenger Saunière, taken in a Paris studio – that the priest then had retouched in a studio in Limoux, the nearest town to Rennes-le-Château! It seems, however, few have wondered whether it could not have been the other way around.

C. The Tombstone

Marie de Nègre d'Ables, the Lady d'Hautpoul de Blanchefort, was buried at Rennes-le-Château in 1781, a century before Saunière arrived in the village. Her tomb, located in the cemetery next to the parish church, was made of two stones, a vertical stele and a horizontal slab. Bérenger Saunière did all he could to erase the inscriptions during the course of his mysterious labours in the cemetery. His demolition work was noticed by the local villagers, who actually lodged a complaint against the desecration.
There is no doubt about the existence of the stele. The slab, on the other hand, was never copied and its precise inscriptions and design are therefore debatable. Its inscription was said to have been published in a work by a certain Eugene Stüblein, a real person but someone who was known only for his works on astronomy and meteorology and, it seems, who was never interested in archaeology. The signature of Stüblein is well-known, but it does not corresponds with his alleged signature on his drawing, appearing at the bottom of the slab. We will revisit this tombstone in Chapter 2.

D. The Nicolas Poussin Painting

The enigma of the painting *The Shepherds of Arcadia* has attained an enduring life in the mystery of Rennes-le-Château. This painting by the French artist Nicolas Poussin has become the focal point of much intrigue, including the 1972 BBC documentary that claimed to reveal a pentagram as the basis for Poussin's composition of the main figures in his painting. The painting shows shepherds inspecting a large tomb. The central question surrounding this painting is whether or not the scenery in the background of this painting resembles the landscape in the Rennes-le-Château area.

In the 20th Century, a tomb similar to the one depicted in the painting was constructed in Arques, some ten miles from Rennes-le-Château. But the construction of the tomb post-dates the painting by three centuries. The question is whether the real landscape around this tombstone corresponds to the landscape of the painting. For the answer to this question, one merely needs to visit the area and observe with one's own eyes. And then it is clear that the countryside bears no relationship to the actual landscape of the Razès. As an avenue of research, it is therefore another dead end.

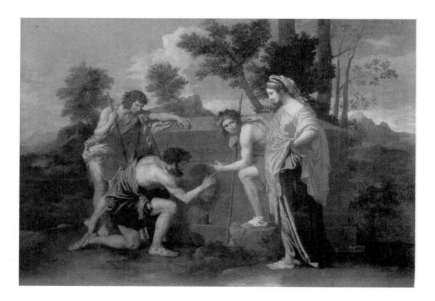

The Shepherds of Arcadia, by the French artist Nicolas Poussin

E. The Abbé Boudet enigma

Saunière was not the only enigmatic priest in the area. In the neighbouring spa of Rennes-les-Bains, village priest Henri Boudet, published a book suggesting that the original Celtic language spoken in the South of France was nothing else but... modern English. The book, titled *La Vraie Langue Celtique* (The True Celtic Language), is such a strange work that various keys to the enigma have been seen in it.

Many authors of have tried to decode it, sometimes surrendering all logic to flights of fancy. For example, some have changed the signature of Edmond Boudet, the priest's brother, who did the drawings and the map illustrating the book, into "aide mon bout d'e", help my "e" project! As French author Jean Markale remarked: if Abbé Boudet had been a priest anywhere other than Rennes-les-Bains, his work would have fallen into oblivion. Instead, it has been republished numerous times, and has even been translated in other languages.

These theories lack a historical framework. Boudet wrote his book in a period when Celtism was fashionable. Many other studies of a similar nature were published. Auguste Callet wrote *La Legende des Gagats* (The Legend of the Gagats), just as in England, Goddfrey Higgins and several others had explored the Celtic and Druid roots of most civilisations, suggesting connections with India, which would then be taken up by other authors, such as Blavatsky, to build another layer on top of the existing "alternative history". In the case of Callet, he deployed treasures of etymological ingenuity to attribute to the Celts all the place names in the town of Saint Etienne en Forez. No-one ever claimed his work was a key to the discovery of a treasure and today everyone considers Callet to be a dreamer, which would surely have been the fate of Boudet, who had the misfortune to exercise his ministry only a few leagues from his colleague, Abbé Saunière.

What might have been of use to Saunière was the map inside Boudet's publication, showing the area of Rennes-les-Bains. This map was much more detailed than the military maps available at the period and therefore no doubt of value to Saunière, if only during his long walks in the area. Alternatively, Saunière might have made use of them in his alleged searches for treasure.

F. The Church's Hidden Clues

Many researchers have pointed to the strange decorations inside the village church of Rennes-le-Château as masking a hidden layer that will set the decoder on the path of the treasure. But as the inhabitants of the village say: "everything was bought at Giscard in Toulouse", meaning that most of the decorations are standard designs and were not created specifically for Saunière. In particular the Stations of the Cross, which have been the object of interpretations, which one can only admire for their ingenuity, was a standard set. Identical sets can be found in other churches, such as Rocamadour. In the same breath, let us examine the "blue apples"-theory. It is true that towards the 17th or 20th of January each year, a light phenomenon can be observed, in the shape of a "blue apple", which was even photographed and filmed, but this is testimony of the skill of the stained glass window fitter. Similar phenomena occur in numerous other churches on all sorts of dates and is definitely not unique to Rennes-le-Château.

It may be that the striking, rococo décor corresponds to Saunière's desire to embellish his church, showing his private beliefs quite clearly to his hierarchical superiors. The rest of his estate speaks out in the same gaudy fashion. Good taste may not have been his main accomplishment – or should that be concern? But the essential question is what possible message could Saunière have passed on in the "treasure hypothesis" by employing this method? The church was decorated while he could still look forward to many more years of his life. To leave a message would be to risk seeing someone else decipher it and steal the treasure away from him.

G. The Priory of Sion and the Merovingian descendants of Jesus Christ

The Priory of Sion was promoted as the holder of the truth of the mystery of Rennes-le-Château... and much more. The Priory of Sion is a mythical order, unknown in the works of chivalry. Purportedly founded by Godefroy of Bouillon when he was King of Jerusalem in the early 12th Century, it is supposed to be a twin order to that of the Knights Templar, but surviving that order's demise, lasting into the 20th Century, governed by a succession of grand masters, called "Helmsmen" or "Navigators". That list reads like a Who's Who in history, including names like the Italian Renaissance painter Leonardo da Vinci.
The story of the Priory was popularised by *Holy Blood, Holy Grail*, the international bestselling book by Baigent, Leigh and Lincoln, in

1982. Later, in France, the myth was added to in novels by Jean-Michel Thibaux. Over the next twenty years, both in France and abroad, the Priory advanced more and more into the public domain and its continued mention in various publications gave it the status of reality.

However, many have tried to demystify the Priory, in particularly French authors such as Jean Robin, Jean Markale and Gérard de Sède, who, in the last book he wrote on the subject, changed his opinion about the Priory and settled the account with his original source and confidant, Pierre Plantard, the alleged Grand Master of the Priory of Sion at its time of international promotion. In truth, the Priory of Sion was nothing more than an association created in 1956, by Plantard, using the "Law of 1901" regulating French associations.

But rather than accepting its true origins, it is claimed that Plantard inherited the Merovingian bloodline that history saw die out with the death of Dagobert II, the last Merovingian ruler. But the legend survived in the mystery of Rennes-le-Château, with the claim that the village became the safe haven for Dagobert II and his surviving dynasty. The fuel for this allegation is found in another parchment, also forged, for which the following decipherment claimed:

A Dagobert roi et a Sion est ce trésor et il est la mort
This treasure belongs to Dagobert II and to Sion and he is – or it is – death

Philippe de Chérisey confessed to the "forgery and the use of forgery" of these two documents, but claimed that two other documents were genuine and were kept in an English bank. Those "genuine" documents detailed a claim of the Hautpoul family, signed by Queen Blanche de Castille in 1244, that they were of Merovingian descent. Whether genuine or not, no-one has ever seen these documents and they can therefore not be subjected to any form of scrutiny.

Conclusion

Although several secondary branches still remain, they also fall by the wayside. So the affair can be pinned down to a few irrefutable items:
- the works in the church and the discovery of the parchments by Saunière in 1891;
- the discovery of the "Knight's Stone", originally blocking the entrance to a tomb in the church, but incorporated by Saunière in the base of his Mission Cross that was erected in front of the church, and what it could have concealed when Saunière dislodged it;

- the works in the cemetery surrounding the Hautpoul tomb;
- Saunière's searches and long walks in the countryside around Rennes-le-Château, as well as changes in his personality, resulting in his short and longer journeys;
- and, lest we forget, the priest's unexpected wealth, which formed the basis of the mystery in the first place.

And that is it. All the rest is confabulation or interpretation, but not fact. One conclusion cannot be ignored: although for forty years scores of researchers have been doing their best to decrypt, decode and decipher, often in the craziest way imaginable, not one of them has got rich except thanks to their florid writings. The more exotic the theory, the more money kept rolling in. But no-one ever found anything. There were lots of possible treasure locations, but most were either empty caves, or what the authors termed "interesting features of the landscape"... but how could anyone become wealthy by discovering – but not even that – by observing a nice looking hill? Or, as some authors allege, sacred geometry, in whatever shape, scale or format? Saunière might only have made money from such discoveries if he were the writer of a book setting forth such a theory. But he did not... So what *was* the source of his wealth? What was he investigating? What is truth? And what is fiction?

Chapter 2
The Hautpoul Tomb

The centrepiece of the Rennes-le-Château mystery is the tombstone of a lady: Marie de Nègre d'Ables, the Lady d'Hautpoul de Blanchefort. After the Albigensian crusade that the Catholic Church organised against the Cathars in the South of France, the area of Rennes-le-Château, as well as Arques and other villages, were donated to Pierre de Voisins. Towards the start of the 15th Century, the Voisins married into the Hautpoul family, and they re-established their claim to the ancient title of Blanchefort. Marie de Nègre had married into the Hautpoul family, the reigning lords of Rennes-le-Château. Widowed and last of her line, she died on January

15

17, 1781. There is a tomb of her in the graveyard of Rennes-le-Château, but there are stories suggesting her tombstone was only installed in November 1789, when it was transported from Serres, near Arques, to the cemetery, by one Guillaume Tiffou. Whatever the scenario, one century later, Saunière allegedly defaced it. Dominique Olivier d'Hautpoul, a distant family member, made a first protest with the mayor of Rennes-le-Château in February 1895.

Gérard de Sède was the first to publish an account of this tombstone in his book *Le Trésor Maudit de Rennes-le-Château* (The Accursed Treasure of Rennes-le-Château), in 1969.
The tomb consists of two parts: a stele and a slab. The existence of the stele is beyond dispute. It was copied in 1905 by a very scholarly society of the Aude region, proving that it could still be seen at that time – a time when Saunière was alive and well in Rennes-le-Château.
The design of the slab as published by Gérard de Sède was taken from an apocryphal book by Eugene Stüblein, which he himself claims to have found but which no-one else has been able to trace. Its origins would have been extremely doubtful, were it not for the existence of a copy, made at the time by Ernest Cros. I will use the reproduction by de Sède, the first publication to reproduce the slab.

Some researchers believe that the tombstone was used to designate an exact point in the local topography. In short, they assume the tombstone is a treasure map. But it should be evident that certain means we have today were not at Saunière's disposal, such as precise maps and the ordinance survey. Any conclusion requiring those maps – a trail some authors have followed, should therefore be highly suspect.

The slab contains the following inscriptions:
- a Latin phrase, ET IN ARCADIA EGO, written in Greek letters;
- a second Latin inscription, REDDIS REGIS CELLIS ARCIS;
- a strange number in Roman numerals, LIXLIXL;
- a bizarre stylised animal.

ET IN ARCADIA EGO
This Latin phrase appears in several paintings dating from the 17th Century, including two paintings by the French artist Nicolas Poussin. The phrase could be translated as "and I also am in Arcadia", or "and I was also in Arcadia". Who is "I"? This is believed to be Death, as the inscription in Poussin's painting is on a tombstone, and hence a parallel to the Hautpoul tomb inscription, which post-dates Poussin's painting by more than 150 years. It is known that in several enigmas, the art of punning is often

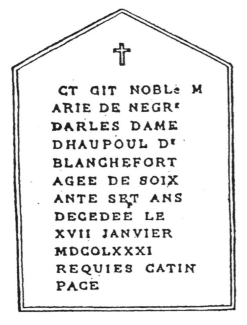

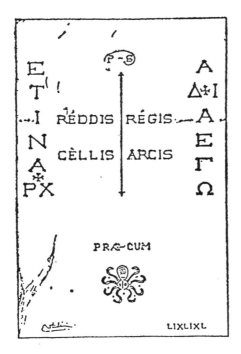

employed as a means to convey a hidden meaning to those that understand both. In some cases, this may not be by means of words, but by some other form of sign, for example the secret handshake of the mason, which to the unaware is no different from the normal handshake, but to those who are aware, reveals him as a mason. In this case, the name Hautpoul could be linked to Nicolas Poussin. In French, "poul" is a chicken, and "poussin" is a chick.

The two interpretations of the inscription assume that it is Death speaking, suggesting death is also present in Arcadia, i.e. we are all mortal. For the Greeks, Arcadia was an abode of innocence and good fortune, the abode of the fortunate, therefore Paradise. So the conclusion of this inscription seems to be that even in Paradise, we cannot escape Death. And if this conclusions is correct, some have argued, this means that somehow, Rennes-le-Château is compared to Arcadia, or Paradise.

Elsewhere on the slab, at the top of the stone, are two letters, P and S, which

have often been interpreted as the initials of the Priory of Sion, but they are also the first and last letters of the Greek word Paradeisos, Paradise. An arrow with a double meaning joins the top point and the bottom point of the stone. To draw an arrow, you must make an "arc", a word that is found in ARCadia and in ARCis. Arc is the phonetic equivalent of Arques, the village near Rennes-le-Château where in 1903, during Saunière's lifetime, a tomb similar to that in Poussin's painting was erected by the Lawrence family. Intriguingly, near Arques is the "Col du Paradis", "Hill of Paradise" and the road which reaches this hill-top passes by the village of Arques.

Unlike Poussin's painting, the Hautpoul tomb inscription is written in Greek letters – but not in a straightforward manner. The transformation of the C into the Greek Khi means that it is the equivalent of CH, hence Arcadia could also be Archadia.

The stylised animal depicted on the stone is most often identified as a spider, because it is convenient to make a pun with the former name of Rennes, Regnes, i.e. spider, "arraigne" in French. However, this animal is more like a female octopus, recognisable by its curved arms and its two large round eyes. The octopus is the symbol of Hell or the Underworld, so it is logical to find it at the bottom, as hell also has the connotation of a lower place. The octopus and its tentacles therefore might symbolise the labyrinth, which is said to imprison spirits.

The double arrow links the letters P-S with the inscription PRAE-CUM. The resulting Latin phrase could be translated as "I will pray for you". The double arrow might also suggest a connection to that old Hermetic adage of "as above, so below". The best biblical parallel is probably in Genesis, where God creates Man "in his own image".

The letters P-S are surrounded by a spiral line and at the bottom the Roman numeral LIX is pronounced helix, the Latin name for the snail. The spiral symbol can be interpreted as the path one has to follow inside a labyrinth. Then again, the "spiral" resembles what in geometry is called the divine proportion. It is the first stage of the unfolding of the Fibonacci Series, but reversed. The Fibonacci spiral usually unfolds anti-clockwise. So perhaps P-S has to be reversed, and it should be read as S-P. Or perhaps the spiral merely suggests the possibility of both, P-S and S-P, which would thus be an inversion, or a mirror.

LIXLIXL

In short, this enigmatic number remains a mystery. However, in the 1970s, one researcher using the pseudonym "Pumaz" circulated several research papers amongst his friends and interested parties. In one, he

demonstrated that this number in Roman numerals is in fact a signature in the form of a numerical key. According to Pumaz, LIXLIXL splits into LIX (59), LI (51) and XL (40). The sum of these three numbers is 150, whereas the sum of all the Roman numbers taken separately is 172. The average of these two values is 161. Pumaz then applied the numbers to the epitaph on the stele. Starting with the R of DARLES, he counted the letters and, at the intervals 59-51-40-161, found I-G-O-U. Since it should read DABLES, and not DARLES (Marie de Negre d'Ables), the first letter in reality being B, not R, the name of Abbé Bigou appears. Bigou was the village priest involved in the burial and making of the tombstone of Marie de Negre d'Ables. The demonstration is complex and without apparent significance, but it might just have been the only method by which Bigou was able to get himself, if only in an informal way, onto the tombstone.

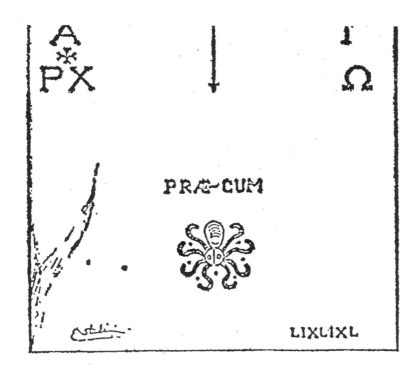

Detail of the tombstone of the Lady Hautpoul. The figure that many identify as a spider is more like an octopus.

REDDIS REGIS CELLIS ARCIS

Many writers have tried to interpret this enigmatic phrase, if it is one, composed of Latin words each of which has several possible translations. REDDIS could be the former name of Rennes, or derive from the word *reddo*, to go.

REGIS could come from *rex*, king, or derive from the verb *rego*, to rule or to direct.

CELLIS is from *cella*, a niche or an alcove built into a wall to hold a statue. Although not commonly used, the word cell also exists in French, meaning, by extension, an oratory or sanctuary. There are other translations, but some spelling mistakes should be allowed for, and then the door is wide open to all kind of fantasies, of which the mystery is already full.

ARCIS could derive from the word *arceo*, to enclose or contain. By changing the letter C into the Greek letter Khi (the equivalent of CH), as in *Arcadia*, this could also be the former name of Arques, Archis.

If we are looking for a pun, then it would mean that some words would not be used according to their proper meaning but for what they symbolise. By taking the final letters IS as a poetic rhyme, rather than as a proper grammatical declension, REDDIS REGIS CELLIS ARCIS could be a sort of maxim: "To Rennes the king, to Arques the sanctuary." Or: "To Rennes the power and material wealth, to Arques humility and spiritual benefits." In this interpretation, the village of Arques would be transformed into the guardian of a spiritual treasure.

On a less speculative note, there is an anomaly in the inscription that no-one seems to have noticed. The words REDIS REGIS CELLIS have each been spelt with an accent, two acute and one grave, which only occurs in Church Latin. This seems to prove the ecclesiastical origin of the epitaph, which has always been linked to the abbé Bigou, who would have been familiar with Church Latin.

However, the same peculiarity is found in the legend on the bas-relief of Mary Magdalene in front of the altar in the church of Rennes-le-Château: JESU MEDELA VULNERUM... And for good measure, this phrase, with the very same accents, is used again for the "large parchment", which, alas, is known to be of doubtful origin.

As a whole, the slab is astonishing in the sense that it is not Catholic in appearance at all: not a single cross, not a single Christian allusion. How strange. Then again, a few items do reveal a symbol of Christ. The spiral surrounding the letters P-S resembles a type of "hat" which appears in a figure called chrisme, which can be seen in certain churches. It is a

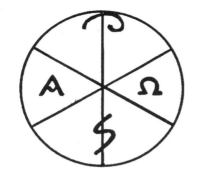

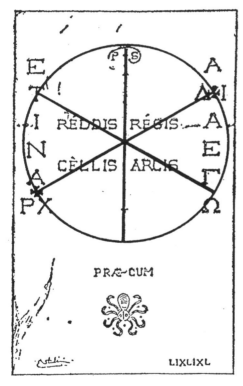

monogram of Christ, since all the letters of the Greek word *Xpistos* (Christos) can be found in it. The chrisme is, in fact, inscribed on the slab: the hat of the P is already there, the double arrow serves as the vertical line to construct the letters P I T, the centre of the text serves as the point to trace the circle of the O, and the arms of the cross inserted in the phrase ET IN ARCADIA EGO can be cunningly used to trace the X. Only the S needs to be traced, a sort of little serpent which winds around the vertical line and progresses symbolically from Hell to Paradise. The letters Alpha and Omega might be missed since the fragment of the phrase on the right, ADIA EGO, begins with A and ends with O.

So where has this brought us? In this possible new perspective on the slab, it is perhaps to Christ that we should attribute the phrase ET IN ARCADIA EGO: "and I also am in Arcadia, said Jesus." Perhaps it is then His tomb that is referred to in the Poussin tomb? With this in mind, in his painting of *The Shepherds of Arcadia*, the shepherds had stumbled upon an interesting tomb... the tomb of Christ?

The vertical stone, the stele, presents even more anomalies and either mistakes or clues, depending on the perspective from which one approaches the enigma. The stele is littered with spelling mistakes.

Are they deliberate, or not? The stone engravers of the end of the 18th Century were not always very literate. They did indeed make spelling mistakes. Sometimes they indeed could not fit in a whole word in the available space. They might forget a letter and add it in afterwards. But where would one draw the line? Eleven words out of 25 are wrong. What noble family would accept such poor workmanship? But more importantly, what family would accept seeing their deceased described as a whore (catin), as a result of a spelling mistake?

These are the eleven mistakes:
- CT instead of CI
- NOBLe instead of NOBLE
- MARIE cut in two
- Final E too small and too high in the word NEGRE
- Ditto for the word DE
- DARLES instead of DABLES
- DHAUPOUL instead of D'HAUTPOUL
- SOIXANTE cut in two
- P too small and too low in the word SEPT
- MDCOLXXXI instead of MDCCLXXXI
- REQUIES CATIN PACE instead of REQUIESCAT IN PACE

To these errors, should be added the following: the blank space in front of CT, plus the inversion of the age and date as, according to tradition, the date of death is indicated first and then only the age of the deceased.

Several attempts have been made to decipher and attach importance to these anomalies. Franck Marie, in R*ennes-le-Château—A Critical Study*, has analysed the stele in a thousand possible ways; in the anomalies he sees the anagram MORTÉPÉE. But this word does not mean very much. Furthermore, MORTÉPÉE has only eight letters and there are eleven anomalies. Marie did not bother with the T missing from D'HAUTPOUL, CATIN does not take his fancy, he uses the splitting of MARIE but ignores that of SOIXANTE. It is therefore clear that the key MORTÉPÉE is doubtful as the answer to the riddle. Furthermore, to make the riddle even more complicated, one could add the letters that are missing, i.e. have been replaced by others: I of CI, B of DABLES and C of MCCLXXXI. The list of possible anagrams would thus become even longer. So let us try a slightly different approach.

If a visual message had to be conveyed, such as an underlying image, then certain letters would have to appear in certain places to make this work. This would mean that on occasion, certain letters might need to

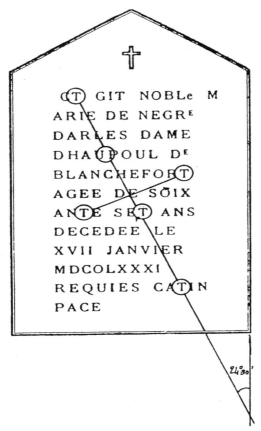

be sacrificed, i.e. either left out, or added in reduced size, so that the "hidden map" works.

Looking at the stele, the first thing that stands out is that the three letters T of the erroneous words CT, SEPT and CATIN are in line. This axis passes between the U and the P of the word DHAUPOUL, where the letter T should have been, but is in fact missing. If we add two other letters T, those of the divided word ANTE and also the T of BLANCHEFORT – the latter the only word in a line on its own – the result is a design in the form of a cross.

Let us not be tempted to try and project the diagram we get onto a map. Abbé Bigou had even fewer precise maps than Saunière. At most, we can observe that the axis of the cross forms an angle of 24 degrees and 30 minutes with the vertical, but such precise measurement might have been beyond the capabilities or purpose of the late 18th Century village priest Bigou. Therefore, what is definitely a possible observation,

23

within the capabilities of Bigou, is that the general form is that of a cross. It is worth noting that the transit of this cross formed by the letters T is only possible thanks to six anomalies: the mistake of the word CT, the blank in front of this word, the T missing from DHAUPOUL, the inversion of the age and date, the splitting of SOIXANTE and the detaching of the syllable CAT forming the word CATIN.

Part II

The Voyages of Saunière

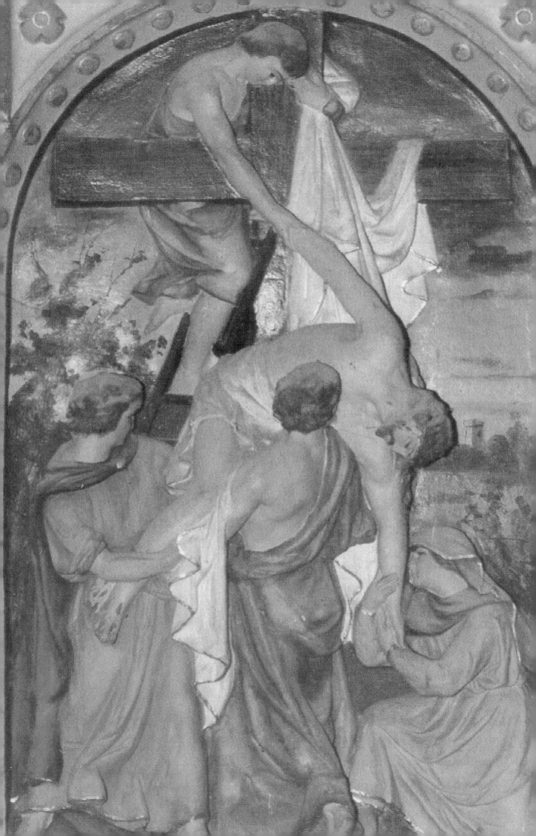

Chapter 3
Masses in Saint Benoit

Whenever one talks about the mystery of Rennes-le-Château, by its very definition, it seems limited to that village. The one dimension that this book will add to the mystery, is that it should not be labelled the mystery of Rennes-le-Château, but the mystery of Bérenger Saunière, as it was defined originally. For this book will show that, contrary to what might be assumed, Saunière was a traveller, rather than being secluded in his home.

In 1973, the following information came to my attention: "At times, Abbé Saunière, priest of Rennes-le-Château, used to go to a little village not far from his parish. He went there to say masses and to have them said... but the main point, it seems, was to conduct researches there, with a great deal of secrecy, into the history, geography, and local traditions. He spoke to one of my neighbours, about 'paintings', sculptures and the wealth of culture contained in this parish. Most of all he stressed the pictures." At present, we cannot reveal the identity of our contact, but we can say his credibility is not in doubt, if only because of his former function.

Few researchers or authors looked into this material. There were, to my knowledge, only two written attempts to make it public. The first was in the newsletter of the *Société du Souvenir et des études Cathares*, number 67, series II, in the autumn of 1975 (page 67). The second was in *Les*

Rennes-le-Château

Archives du Trésor de Rennes-le-Château, by Pierre Jarnac, published in 1988 (pages 259 and 260).

This second mention was not followed up by further research, even though it received a wide distribution. It was a 595-page long reference book offering a complete catalogue of everything that was written on the subject of Rennes-le-Château.

The first article, thirteen years later, was signed "Elie Kercorb" and

The church of St Benoit, near Chalabre

appeared in a magazine that was only distributed to members of a society devoted to Cathar studies, based in Arques. It mentions an early discovery, both a treasure and an archaeological find, made by Saunière. Kercorb then alludes to the discovery of historical documents of interest to numerous enthusiasts and ends by stating that it was the church of St Benoit that, on numerous occasions, was the destination of Saunière's travels.

St Benoit is a little village in the department of the Aude, near Chalabre. By road, it is about thirty kilometres from Rennes-le-Château, a bit less by pathways. The river running through the village is called the Ambrone. During roadworks, ancient remains were discovered underneath the village, but the underground tunnels were immediately blocked up again. Although such finds are not uncommon in this region, they are proof of a very ancient occupation.

The church itself is situated along the road, being too big for the village as it is today. We have proof that Saunière went to this church to celebrate mass. In the *Dictionnaire Topographique du Département de l'Aude*, abbé Sabarthès lists the various dedications of this church: St Agatha in 1319, under the vocation of St Benezech from 1389 till 1589, of St Benazet in 1594 and finally, St Benoit, from 1758 onwards.

The building seems to be the remains of a former Benedictine monastery, which appears to be backed up by an inscription inside the church. Some aspects of the church suggest it was fortified. Since 1995, the graveyard in front has held the remains of Jos Bertaulet, a Belgian-born researcher who discovered an enigmatic vault in Notre-Dame-de-Marceille, near Limoux, which seems to be connected to the mystery of Rennes-le-Château.

The church itself, particularly its interior, is almost derelict; very little remains of its former decoration and ornaments, which are in a very sorry state. In the side chapel to the left on entering, is a "cipher" formed by interlacing the letters S and B, of St Benoit. But they are, when mirrored, also the initials of Bérenger Saunière; an interesting coincidence. At the bottom of the nave, some very ancient tomb crosses are placed against the wall. They bear a hand on the right side and a builder's tool on the reverse. These funerary crosses are not unique, even though they are not common in this region. They are clearly the tombstones of a builder, either a mason or a carpenter, but there is not a single means to identify the individual buried: no name, date or dedication. On the back there is only a picture, apparently the logo of the corporation he belonged to. Perhaps they are the gravestones of two members belonging to the "Cagots", well known for their carpenters and masons. If so, they would not have been appear in any Church register, as they were the last survivors of the Cathars.

But fortunately that which seemed to interest Saunière most in this church is still there: two paintings, on the right hand wall of the nave. Though very dusty and in a bad state, they are still intact and, more importantly, legible. The two pictures probably date from the end of the 19th Century and are of quite heavy-handed workmanship and of a doubtful style (see page 32-33).

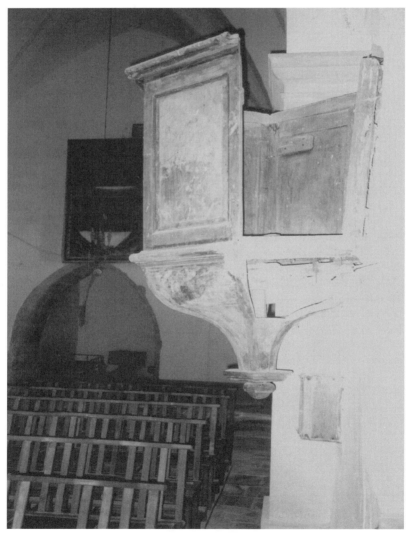

The interior of the church of St Benoit, in urgent need of repairs

The first picture shows the head and shoulders of a man of noble appearance, wearing a red cloak over a green habit. His face, with long hair, full pointed beard and moustache, is looking up to the top left hand corner of the picture, where three rays of yellow light are beaming down. He seems to be in adoration and the open palms of his hands are turned towards a book with the pages opened out. In the foreground lies a magnificent sword, the hilt turned towards the figure. The blade of the weapon is steel coloured and the point is golden in colour and highly decorated.

The book is open and flat, horizontal. On two of the pages the writing is an unformed scribble of red and black lines. On the left hand page there are eight red lines and fourteen black ones. On the right hand page, there are six red and fourteen black lines. Looking closer, we can see some letters, all of them red, which are quite large and well drawn; they begin the lines of false writing. Taking them in the usual direction of writing, from left to right and from top to bottom, strictly speaking they do not signify anything. But when read in a column from top to bottom, one can read, on the left page, SAULE QUID, and on the right page, "MEPERSEQ". Or in Latin: SAULE QUID ME PERSEQ.

Saule is a vocative of Saulus, the birth-name of Saint Paul the Apostle, who changed his name from Saul to Paul after seeing an apparition of Jesus shortly after Jesus' Resurrection. *Quid* is the interrogative neuter of "what", "what is it that". *Me* is a personal pronoun, the first person accusative. *Perseq* offers several possible translations as we do not have the ending: to follow obstinately from one goal to the next, to continue to follow; to pursue – fugitives – justice; to stick to a pursuit; to follow someone until you reach him, to bring to an end, to accomplish, to recover (money), to collect; to peruse in writing, to put on view, to tell stories.

So we could read this phrase as: St Paul what is it that continues to follow me? St Paul what is it that pursues me? St Paul what is it that sticks to me in pursuit? St Paul what is it that makes me recover money? St Paul what is it that is written of me?

Interesting questions, but no way of telling whether this was what interested Saunière or not, or even what meaning was intended by the maker of the paintings, if any meaning at all should be read into the letters.

In the second picture, the person is crowned with a halo, this time found on the right. The clothing is more modest, a simple blue shirt fastened to the neck with three buttons. He has less hair and the top of the head is bare, the beard is less thick and round in shape and he too wears a moustache. His face looks up to the top right of the

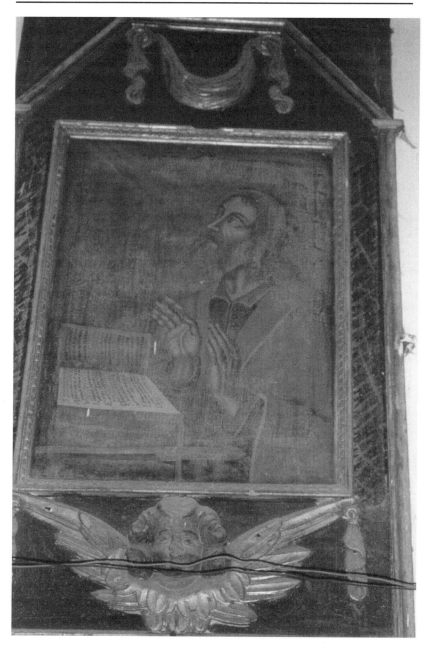

The two paintings inside the church of St Benoit, showing two saints in prayer. Note the two books.

picture, not in the direction of the rays of light but towards... a cockerel. The hands of this man are joined, the fingers interlocked. The subject appears to be praying to the cock. Under the cock there is an open book but this time it is practically standing on end, vertically. In the foreground of the picture are two keys bound together with a small red cord.

Again we find the same style of simulated writing on the book. The set of well-drawn letters is here present as well, but with a different lay-

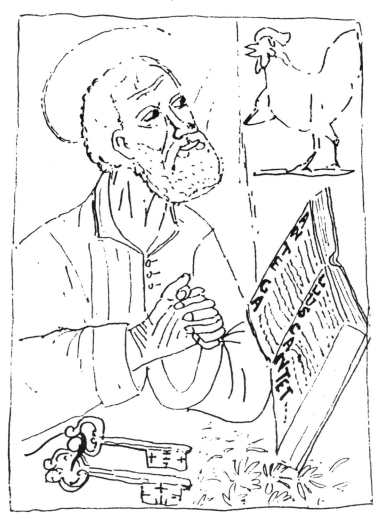

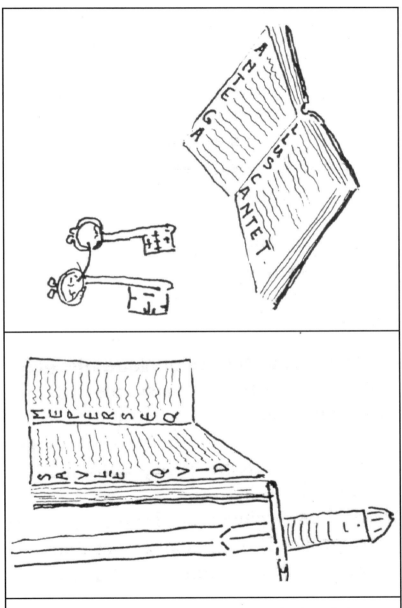

Details from the two paintings, showing the two books with the writing. One book is accompanied by keys, the other by a sword. They are referring to biblical texts on the Passion of Christ.

out. On the left hand page are three red and nine black lines, on the right hand page there are four red and six black. On the latter page, the last line is completely made up of drawn letters and the last word is grammatically complete. The vertical column can be read in the same way as the preceding book: the left hand page spells out ANTE GA and the right hand page, first vertical, is LLUS CA, and the last line is NTET. "ANTE GALLUS CANTET."

Gallus is Latin for cock, immediately proving that our attempt to read some meaning in these capital letters is not a folly; the cock is depicted on the painting itself. *Cantet* is the third person singular subjunctive of the present tense of the verb *canto*, to sing. *Ante* is an adverb, meaning *previously*, *before*. "That the cock crows before." But *ante* could also be *antequau*, a subordinating conjunction meaning *before*. This would give us "before the cock crows" or "cock crow, the crowing of the cock."

Two pictures, one depicting St Paul, recognisable by his sword, the other showing St Peter, identifiable by his keys. It was St Peter who would betray Jesus before the cock crowed, which happened on the evening before Jesus' arrest, while Jesus and his followers were staying on the Mount of Olives.

St Paul is identified by his real name, Saul. He had, as mentioned, a vision of Jesus on his way to Damascus and once there, he changed his religion and became one of the promoters of the church of Jesus. When he was baptised, he wanted to change his name, but he merely changed from Saul to Paul, i.e. changing the first letter S to a P.

So S becomes P... is there a connection to the P-S, inverted to S-P, on the Hautpoul tombstone? This connection is far-fetched, but what is clear is that the two pictures do show lots of inversions, and mirrors: a horizontal book as opposed to a vertical book; one person looking to the top left corner, the other to the top right. And what about the sword, the symbol for fighting, as opposed to the keys, which, being connected to St Peter, suggest the kingdom of heaven? Or a connection with the book, the symbol for knowledge? Is the message of this painting that somehow, there is a link, of opposites, or mirrors, between Paul and Peter? Are the pictures themselves not identical, although mirror images, except for certain details? In fact, might we not call the first picture "To the Sword" and the other "To the keys", if only as a means of distinguishing them? So is there in these two paintings a message of a material and a spiritual aspect?

In Christian mysticism, the Church of Peter, of Rome, is often linked to ROMA, the worldly aspect. At the same time, the inverse, i.e. AMOR, the Church of Love, is seen as the hidden stream running through

Christianity, symbolising the spiritual aspect of the Church. Is the latter here associated with Paul? But, intriguingly, again using mirrors, it is clear that Peter in the painting is associated with the keys, not the sword, i.e. the spiritual, not the material! Inversion and mirrors are all around, and when Saunière was in this church, he must have observed the paintings. One can only wonder whether he arrived at the same conclusion.

Later, I contacted "Elie Kercorb", who insisted that her anonymity should be maintained. She had spent a lot of time in St Benoit and had received copies of several letters from one elder woman in the village. These letters proved that Saunière had come to this area on several occasions, as these were the letters she mentioned in the 1975 article. She further learned that the visits of Saunière were not noted, which meant that they did not occur by car or any other mode of transport. In fact, most likely, Saunière walked the distance. After all, he was quite famous around Rennes-le-Château for his long walks. At that time, the landscape was still a grid of several small paths running across the land. Many of these were hundreds of years old, following the natural lay-out of the land, twisting and curving towards their goal. Those were the paths that Saunière most likely walked.

Elie Kercorb had started her study around 1965, after she had spoken to the local people, the farmers and hunters, who had used those paths at the beginning of the 20th Century, the time when Saunière used them. She traced them on a map. After several years of arduous research, she discovered that near St Benoit, on this route, was a small necropolis,

Finds by Kercorb in the ancient necropolis of St Benoit

known as late as the 17th Century and marked by an oratory that was almost completely unknown. In the end, the oratory fell into disrepair and was replaced by a cross, which had disappeared at the time of her research. Elie did find certain stones left behind, including a stone showing two heads.

Along the path, certain stones could still be found in 1970 and it is clear that those markers were in place when Saunière walked the path to reach St Benoit. Was he interested in the ancient necropolis? If, as some believe, his treasure involves a secret

linked with the survival of the Merovingian bloodline, he must have been. But, unfortunately, it is unlikely that is indeed the key to the mystery. The village of St Benoit captivated his interest, but the exact nature of this attraction, apart from the paintings in the church, can no longer be seen, except perhaps under the thick undergrowth. Fortunately, elsewhere, there are clearer signs of Saunière's presence.

Chapter 4
Visits to neighbouring Arques

Arques is situated to the east of Rennes-le-Château, beyond the neigh-
bouring village of Rennes-les-Bains. The earliest mention of the castle of
Arques dates from 800 AD, when count William was asked to guard the
castle "for the king of France", who, at that time, was Charlemagne.
After the Cathar crusade, ownership of the castle and surrounding area
passed to the Voisins family, as reward for their help in rooting out the
Cathar heresy.
The Lord of Arques, Pierre de Voisins, also went on the crusades to
Palestine. His contingent was led by Guillaume of Roussillon, the lord
of Châteauneuf, and a name we will come across in the next chapter,
as he originated from the Pilat region, near Lyons. The crusade was led
by the Grand Master of the Knights Templar, Guillaume (William) de
Beaujeu.
Later on, the ownership of Arques passed to the de Joyeuse family,
when the last descendant, Francoise de Voisins, married Jean de Joyeuse
in 1518. One century later, the de Joyeuse family also had a strong
connection to the Pilat region, and particularly with the de Gaste
family, who would acquire the Lupé castle, to which we also shall
return in the next chapter. Anne de Gaste married François de Joyeuse
and Claude de Gaste, her brother, married Françoise de Joyeuse, the
aunt of Cardinal de Joyeuse. A double alliance, making sure that the
bonds between the two families was sealed for eternity, and that the
lands of Arques and those of Lupé in the Pilat remained affiliated. And it
is a link that might have escaped many researchers since, but not the
attention of Saunière, it seems.

Arques is currently best known for two things: its castle outside the
village and the house of Déodat Roché, which is now a museum containing
Arques' former mayor's studies into Catharism. One of Déodat Roché's
parents was a notary, and he assisted Saunière in many of his transactions.
Another of Déodat's family member was a doctor, in fact, a doctor
who was one of those present at Saunière's deathbed. Déodat Roché
himself was not just mayor of Arques, neither was he "just" someone
who brought research into Catharism back into the popular imagination,
He was also a high-level Martinist and a mason with the French Grand
Orient. As such, he had a unique perspective on local history, current
events, direct experience of Saunière's life, and much more. Together
with his trusted secretary, Lucienne Julien, he constituted a veritable

inspiration for my research – and a source of invaluable information.

A third building, next to the house of Déodat Roché, used to be well-known, but has now faded in obscurity: the village church. Before the Revolution, it was part of the bishopric of Alet and had John the Baptist as its patron saint. After the Revolution, the patron saint became St Anne. It is part of the congregation of Couiza, the village situated at the foot of Rennes-le-Château, and hence in the diocese of Carcassonne.

The church contains some relics, in particular some bones of John the Baptist as well as a fragment of the cross of St Peter. Interestingly, the relics of Arques were brought from Palestine to Arques by Pierre de Voisins upon his return from the Crusade. The relics were cherished by Cardinal de Joyeuse, the uncle of Françoise de Joyeuse, who had married the Lord of Lupé, in the 17th Century. The relics are held in a side chapel, in a niche. Protected by safety glass, one can see the venerated contents: the bones of John the Baptist. But in spite of all the respect due to this character, it is not clear why so many dignitaries should take such an interest in these relics. The truth may be that the old mounting was coveted more than its worthy contents. It is a fact that the Cardinal de Joyeuse was most interested in the container itself.

Two centuries later, Saunière investigated Arques. Shortly after his visits, he contacted a goldsmith and a dealer in precious stones, both located in Lyons. One can only wonder whether there is a connection with anything he found in Arques... or elsewhere.

Some possible physical evidence of his presence still remains inside the church. Behind the main altar, on the left, are two signatures, which read as "Saunière". Are these the autographs of the priest himself? A glance in the vault on the right-hand side reveals that inside a niche, under a pane of glass, is a very beautiful "Jesus of Prague", similar to that which Saunière kept in his villa in Rennes-le-Château.

The church of Arques contains three interesting paintings. One is the so-called "Jewish Christ". This painting, flanked by two statues, one of John the Baptist and the other of St Anne with the child Jesus next to her, is of a dead Christ, hanging on the cross. Blood flows down his side from the spear that had entered his body there. The hands show the signs of the crucifixion and even though his eyes are still open, they are lifeless. Blood has dripped on the crown of thorns. His halo is located between the wood of the cross and the words "INRI". His feet have been nailed with just one nail, the right leg on top of the left. The painting was made in 1941, by Ernest Bott, from the city of Frabo, i.e. Fribourg, in Switzerland. Because of the Second World War, Jews were on the run and Arques was one of the places where some were sheltered in secret. One of the persons in charge of the maintenance of the church sheltered some and

apparently as an appreciation for his help, one of his "lodgers" created this painting.

The second painting is far older, from the 17th Century, and was commissioned by the bishop of Alet, Mgr. Nicolas Pavillon, and painted by Reynaud Levieux. Pavillon was a notorious bishop, involved in attempts to oppose the French throne of Louis XIII and his successor, Louis XIV, the Sun King. Alet became a hotbed of resistance, not only against the State, but also against the Church, for Pavillon was involved in a radical movement, Jansenism, which tried to return the church to its original values.

The connection between Pavillon and Levieux was via Jean Pavillon, a nephew of the infamous bishop, who was a student of Levieux. Nicolas Pavillon ordered an entire series of similar paintings, one of which was to be displayed in all churches of his bishopric. Intriguingly, Levieux was a friend of Nicolas Poussin, whose name is intimately linked with the mystery of Arques.

The third painting hangs next to the entrance (see page 43). Nothing is known about its provenance. Neither the name of the painter, nor the date of execution or who commissioned it is known. It is a representation of what could be labelled the "holy family", but I have re-baptised it as "The child Jesus with the pear".

The setting is in the form of a perfect square. We find the Holy Family joined together; on the right-hand side, upright, the tallest of the characters, Joseph (with halo), with both hands supporting him on a kind of stick or cane. In the centre is the Virgin Mary (with halo), seated, holding on her right leg, and therefore lower than her own face, the child Jesus (with halo). Finally, on the left is a fourth character, slightly lower than the Virgin Mary. It is a very old woman (with halo), kneeling, looking intently at the child Jesus, offering a strange fruit to him. Behind these characters are three large areas, painted plainly in three different colours.

Some symbolism is clearly present in the painting. On the right-hand side behind Joseph, the bottom of a twilight landscape can be distinguished, barely illuminated at its base by a diffuse reddish glow. A tree with bunches of leaves finishes the painting on the right against the frame. If we look carefully at the trunk of this tree, we observe what looks like a snake winding round the tree in a single turn. Could it be the Tree of Knowledge, or the Tree of Life, in the Garden of Eden, with the Serpent of Knowledge? Elsewhere, above Mary, in a luminescent oval, a large bird flies over the scene, spreading its wings. It is the Holy Spirit, in the form of a dove. The old woman on her knees offers a pear to the child Jesus. A pear, rather than an apple, as was the case in the Garden of

Eden, with the serpent offering the apple to Adam and Eve. Adam and Eve, who plunged the world into sin, as opposed to Jesus who died to save us from sin. The apple of Adam and Eve, as opposed to the pear of Jesus?

Three of the characters' identities are clear: Joseph, the Virgin Mary and the child Jesus. But the fourth person's identity is doubtful. Nothing in the bible suggests the identity or the presence of this fourth person. The only possible reference is to the Three Magi, offering gifts to the baby Jesus, but it is clear that that imagery is too far removed from what is depicted here to make sense. Perhaps it is St Anne, the patron saint of the church, who somehow needed to be woven into the picture because of her patronage of the church in which the painting hangs. Perhaps, but also perhaps unlikely.

It is possible that this painting illustrates a chronology, both symbolically and biologically. Joseph was already an old man by the time he took Mary as his wife. On the painting, he is depicted arched, leaning on a stick... but still upright. The features of his face are serene, the beard is grey. However, his appearance is not wrinkled and does not portray the idea of advanced old age. Moreover, there is no sign of baldness – on the contrary – as the painter has provided him with abundant, well kept hair.

Mary is much younger than her husband, at the right age to have children. The child Jesus is very young. The woman 'with the pear' seems ageless. Biblically, one could compare her with Saint Anne. However, according to biblical texts, she should have roughly the same age as Joseph. This woman seems overpowered by age, and is sitting on her knees. The features of her face are very wrinkled and show her great old age. And if it is Saint Anne, why should she be depicted as sitting in darkness?

Several possible levels of interpretation of this painting are possible. At the most basic level, it is a religious scene, quickly scanned by those entering and exiting the church. But on another level, it seems a transition from one state to another. We pass from the creative feminine phase by the intervention of the Holy Ghost to a divine or sacred plane... into a phase much less visible, or creative... but a creative exit of a field with end, age, or name. As if the passage through a religious or biblical world enters into a deep, esoteric world, a transition accomplished by the life of a child having to die, one day, in an initiatory way (remember how 33 years are cherished in esoteric circles). Finally, to re-appear in a different, but secret form. Joseph does not touch the child, but Mary holds the right hand of Jesus (from the viewer's perspective), who himself holds his left hand towards the old woman.

42

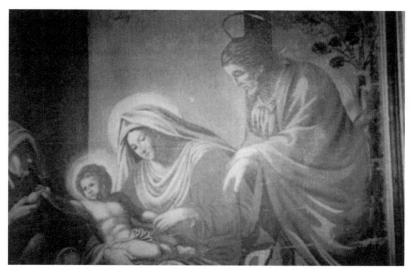

The so-called picture of "Jesus with the pear" in the church of Arques

He does not touch it, but the transition will be made only by means of a fruit… the carrier of seeds… the hope of fecundity and the perpetuation of the species.

Perhaps the old woman is not the grandmother of the child Jesus at all, but instead the Great, Universal Mother, whom one finds within the fertile depths of the old caves of the forgotten, but ancient, generative rituals, which were quickly taken over by the Church, in the shape of the Black Madonnas, in the new form of "Matrones", the feminisation of the word "patron", within the meaning of a "legitimate wife", in the language of the Romans. Indeed, rumour has it that somewhere in a private building in Arques, a Black Madonna may still be found. But let us not digress…

The bond between the different generations is presented by the intermediary of fruit. The choice of fruit would, no doubt, not be without meaning for the painter. That fruit is a pear. On a purely religious level, the pear is hardly a powerful symbol. It is even scorned. It does not have very flattering connotations: in French, "to take somebody for a pear" means that that person is easily deceived. "A good pear" is a person whose credulity one can easily exploit.

One characteristic of a pear tree is its trunk, which is said to protect the cattle and to divert lightning. Because of its agreeably sweetened taste and its abundant juice this fruit symbolised Venus or its Greek counterpart Aphrodite. Also undoubtedly on account of her round and soft forms, it inspired the eroticism, symbolising woman, love. In religion, this fruit

is considered to be a bad symbol and does not represent a model of uprightness or an example to be followed. On the other hand, the apple that would prove so extremely expensive for Adam and for Eve is often found in symbolism.

The apple is the fruit of temptation. In the bible, it is defined as the fruit of knowledge. Of all the fruits the biblical authors could have selected for this role, they chose the apple. A strange choice. Why? It seems to be because of the fact that the apple represents both the male and feminine principle, the evolution of the species.

On a completely symbolical level, this for an extremely simple reason: take an apple, cut it in half, on the horizontal plane. Each time you do so, you will find a star, a round slice with five branches, i.e. a pentacle, the image of the upright man. In symbolism, this Upright Man is the connection of the sky with the earth, as well as being the most powerful magical sign. Cutting the apple vertically in half, and though simplified, the female genital apparatus is visible in astonishing detail. The apple is therefore the symbol of Male and Female, depending on the horizontal or vertical slicing of the "globe" of the apple. This slicing is identical to the sign of the cross, as done by the priest in front of the congregation: vertically, then horizontally. And it is this Cross that would become the symbol of Christ, 33 years after his depiction here as the Child Jesus, when he was merely the first result of the "seed", when he had just "sprouted", yet to grow into Jesus, and then into Christ, who would give his life for all Mankind, so that all of us could be reborn in Heaven, without sin, as the Christian doctrine states.

The apple literally seems to contain both sexes in union, which is exactly the "act" for which God got upset with Adam and Eve, and it was this "knowledge" that Lucifer, often depicted as the serpent in the Garden of Eden, brought to man. But even though Lucifer is present in the painting inside the church at Arques, as the serpent encircling the tree, the apple has been replaced by a pear.

Comparing apples to pears, the pear is clearly longer. The prevailing detail, however, is in the leaves attached to the fruit as depicted in the painting. Information gleaned from botanical documents showed that this particular fruit-bearing category is now practically extinct. It is a species of small, almost wild pears. The flesh was very granulous, of a not very pleasant consistency, with a rather insipid taste. The skin was thick and hard. A description can be found in the botanical census of fruit-bearing species ordered by Napoleon I. Even then, it was already stated that this tree was cultivated hardly anywhere. Neither was it very productive, giving few fruits with a taste that was non-existent... and seemingly only used for consumption on animal farms or growing wild.

44

The botanical description mentions that the characteristic of this pear is to have small leaves fixed on its stalk, rather long, numbering from two to five. But above all, its name is remarkable: after giving its Latin name, the census also states its popular name, used until the end of the 18th Century: the Mary Magdalene pear. And it is with this saint that we have returned to one of the characters so prominent in the mystery of Rennes-le-Château: from her being patron (or matron) saint of the church of Rennes-le-Château, to recent speculation by international bestselling authors that she was both the wife of Jesus and the mother of his children, as well as the medieval legends or accounts of her voyage to France, where she allegedly spent her last years – as we shall see in the next chapter.

Biting deeper into the pear: the word "pear" in Occitan is "péro", in French "poire". "Little pear" in the language of the Languedoc is "pérot"

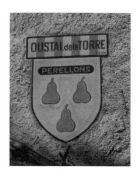

in the Corbières and "peron" in the High Loire and Pilat region. Sometimes the R is doubled (perron) or intensified, resulting in "porron".

In heraldry, it is extremely rare to see the pear depicted on a coat of arms. The only coat of arms of any distinction using pears, and at least three of them, is that of the Lords of Perillos. Furthermore, though the depiction of the pears on this coat of arms varied throughout the ages (sometimes no doubt due to human error), the pears depicted are of the species of "Mary Magdalene pears".

Perillos is now an abandoned village near the Mediterranean coastal town of Perpignan. Alhough one Lord of Perillos was once Grand Master of the Order of Malta, donating pieces of art still on display in their museum in Malta's capital Valletta, the village has been abandoned for the past fifty years. To quote P. Maureille: "The village disappeared on the day that the country families physically died out. From then on, the problem was no longer geographical, but medical-social and medical-moral. The war of 1939-1944 led to the Perillos habitat becoming deserted…"

Can there be a link between that region and Arques? One link is the infamous Bigou, a predecessor of Saunière, the person who created the tomb of Lady d'Hautpoul in the cemetery of Rennes-le-Château, the tomb that would fall victim to the destruction of Saunière. Bigou visited Arques occassionally, including its church. But this is not evidence

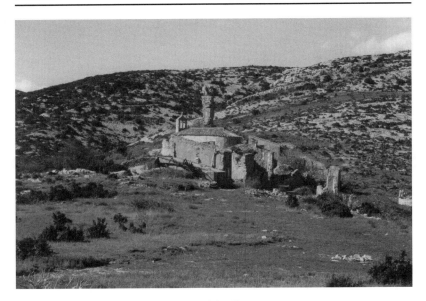

View of the now deserted village of Perillos

of a link between Arques and Perillos, merely between Rennes-le-Château and Arques. One direct link can be found in the strange notebook of a certain 'Monsieur de Mont-Marquest'... dating from the 18th Century. Raymond de Mont-Marquest, a kind of local scholar, kept a diary of the talks he attended and that seemed to him of notable importance. This curious, and very instructive document (in our possession) mentions questions of Bigou and has listed the keywords: 'Rennes', 'Arqueès', 'Ospoul', 'Périllost' and 'the SANCTUAIRE'. Opoul is the neighbouring, now twin, village of Perillos and its name bears a remarkable phonetic similarity to Hautpoul. In fact, it is known that the Hautpoul family did indeed originate from Opoul-Perillos, which might explain Bigou's interest in this region, as he was, after all, chaplain to the family.

The word 'Sanctuaire', sanctuary, indicates the holiest place of a building devoted to worship and is generally prohibited to all except the faithful. For Jews, "sanctuary" was the Temple of Jerusalem, where the Ark of the Covenant resided. For the Christians, sanctuary is the High Altar or the tabernacle in the church. The "Highest Altar" is the one in Rome, in the Vatican, inside St Peter, where only the Pope is allowed to say mass. The Greeks viewed the sanctuary as a sacred enclosure, sheltering either a tomb, or a place of purification, a statue of a god, etc.

Another link between Perillos and Arques is most likely completely coincidental. The abandonment of Perillos started in 1895, but ended

The plateau of Opoul, on top of which sits a castle, as well as a chapel called "Salveterre"

during the Second World War, when only one person, Antonin Pujols, was still alive in the village. After he left, the houses degenerated. Only the chapel and the cemetery were maintained and to this very day, an occasional mass is held inside the chapel. The coincidence lies in the fact that the family of Antonin Pujols interred his remains in a family grave, located along a road, situated just outside of the village of Arques, on the road to Couiza, and hence Rennes-le-Château. Coincidence travels in mysterious ways... almost as much as the strange wanderings of Saunière, it seems.

Chapter 5
Trips to Lyons and the Pilat region

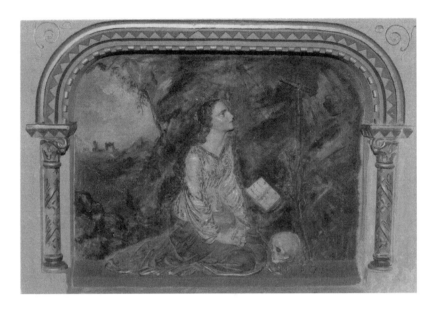

One of the enigmas of Saunière's church is the picture of Mary Magdalene on the front of the altar, in the middle of the central aisle. This is not surprising, as the village church was dedicated to this saint. Saunière added several "Magdalene themes" to it: a stained glass window where the saint can be seen in a boat, a statue inside the church, one outside, then the naming of his villa as the Villa Bethany, where Mary Magdalene met Jesus, and the Tour Magdala, named after the home of Mary Magdalene, a town on the edge of Lake Tiberius. As a result, most speculation has drifted in this single direction: Mary Magdalene and particularly her relationship with Jesus, with each item of the puzzle left behind by Saunière having been used in various roles.

The most enigmatic of all is believed to be the bas-relief of Mary Magdalene on her knees, with her hands crossed, at the foot of a rustic cross composed of two branches of badly pruned green wood, bound together with a knot; some leaves are still growing along the vertical branch. In front of her is a human skull and an open book. A dark grotto is used to frame the scene, but through a wide opening, a landscape lit by the setting sun is visible.

It is a classical and traditional representation of the saint. The grotto is the cave where she is believed to have finished her days. During the Middle Ages, a Christian legend stated that Mary Magdalene had come to France, and had ended the final years of her life, inside a cave, in St Baume, in a French region called Provence, near the Mediterranean Sea.

It is interesting that Sainte Baume is translated as Holy Balsam, biblically connected to Mary Magdalene, as she was said to have placed balsam on Jesus' feet. She is therefore often depicted as holding a jar, containing the balsam.

The Church recognises only one Saint Mary Magdalene, but the gospels distinguish between the repentant sinner, whose name is not mentioned, Mary of Bethany and Mary of Magdala. The Church has amalgamated these three possibly distinct women into a single saint. On the second day after the death of Jesus, some women had prepared perfume to embalm his body. When they arrived at the sepulchre, they found it open. Some angels told them about the resurrection, but it is

The Tour Magdala, named after the birtplace of Mary Magdalene, and the statue of the saint inside the church of Rennes-le-Chateau

Mary Magdalene who was the first to witness the resurrected Jesus. This placed her well above the apostles, to whom, logically, one might think he would want to appear first. Several gospels, some apocryphal, make it clear she was very close to Jesus, closer even than several apostles – some of whom, Peter in particular, it seems, hated her. The Roman prayer book drafted by the monks of the abbey of Hautecombe concludes that "she became the best friend of her saviour". According to some modern authors, she and Jesus were even married and the famous wedding in the bible at which Jesus performed miracles, was actually his own. Indeed, it was only in 325 AD that, on Emperor Constantine's suggestion, the Council of Nicea voted on the divine nature of Jesus, despite the contrary opinion of a great majority of bishops, who saw Jesus as only a man, inspired by God perhaps, but not God himself. Jesus' divinity was literally the subject of a ballot – he was voted by humans to be the Son of God, long after his death – or resurrection.

The official Church history states that after the Resurrection, Mary Magdalene followed the Virgin Mary and Saint John to Ephesus, a Greek town in Asia Minor, where she died. It was in Ephesus that the cult of Mary Magdalene became confused with the cult of Artemis, whose temple at Ephesus was among the Seven Wonders of the World. Ephesus was also the town of the "seven sleepers", seven young Christian martyrs who were walled up, alive, in a cavern, where they fell asleep and woke up two centuries later. This supernatural event was explained by proclaiming the cave was sacred, as it was the place where Mary Magdalene had been buried.

But in France, other legends can be found about the fate of Mary Magdalene. One legend sees her crossing the sea in a boat without a sail or an oar, accompanied by Lazarus, her brother who was raised from the dead by Jesus, Martha, her sister, Maximin, Mary Jacob, the sister of the Virgin Mary, Mary-Salome, the mother of the apostles James and John, and their servant Sara. Again, a clear reference to the number seven, i.e. seven occupants.

The boat was said to have landed on the coast of the Camargue, where Mary-Salome, Mary-Jacob and Sara stayed. The remaining four departed and each went their own way. Mary Magdalene allegedly travelled up the coast to the east and then, always travelling in the direction of the sunrise, came to the foot of a huge mountain, which she began to climb, to find a refuge and a place to continue to expiate her sins. It was said that a star guided her to the grotto and the archangel Michael killed a dragon that had lived there for thirty-three years. It was said she was dressed only in her long hair, nourished only by roots and quenching her thirst with water from the heavens. Sensing her approaching death,

she warned Saint Maximin, who gave her the sacraments and placed her body in a mausoleum. The basilica of Saint Maximin was raised on the spot where her tomb was placed and where the relics of the saint are still venerated.

This is one legend, but by the time of Saunière, there was another place in France that lay claim to holding the relics of Mary Magdalene: Vézelay. Saunière knew that relics of Mary Magdalene were venerated at Vézelay. The abbey in Burgundy was a centre of pilgrimage that rivalled Sainte Baume. The abbey in Vézelay was originally dedicated to Saints Peter and Paul and was founded by Gérard de Roussillon around 860 AD. At that time, Gérard de Roussillon was Count of Barcelona, Narbonne, Gascony, the Auvergne, Provence and Burgundy and his valiant exploits made him the hero of several heroic poems.

During the 12th Century, rumours spread that the abbey in Vézelay housed relics of the Magdalene. But where had these suddenly come from? The monks kept the mystery going for a very long time, but then claimed that someone called Baidilon had gone to Sainte Baume to carry them off on the orders of Gérard de Roussillon.

Gaston Duchet-Suchaux and Michel Pastoureau in their book *La Bible et les Saints* (The Bible and the Saints) are two of many who argue that the Vézelay claim is without any historical foundation and that the monks invented the story, in an effort to boost their economic prosperity, i.e. becoming a site of pilgrimage. Because of Vézelay's counterclaim, the

Drawing of the altar piece depicting Mary Magdalene praying in front of a wooden cross, inside a cave, with a skull at her knees

residing monks at St Baume did a detailed search in 1279 and found a tomb, and a body, which to them were the true remains of the Magdalene. It was the counter-attack of St Baume to safeguard their income.

But back to the bas-relief. The grotto where Mary Magdalene is praying might therefore be the one in Asia Minor, St Baume, or another grotto… we do not know. The book near here is the gospel on whose teachings she is going to meditate. The skull could be that of the apostle James the Greater, one of the relics brought back from Palestine by the "Saint Marys of the Sea", as the seven travellers in the boat became known (as most of people on board were called Mary). Both the book and the skull, like the grotto, are her traditional attributes that can be viewed in many depictions. All the representations of Mary Magdalene in France are almost identical and possess the same details.

Going into detail, Mary Magdalene on the bas-relief is not looking towards the cross. Rather, she glances off at an angle of eighteen degrees in relation to the altar and her eye is fixed on a certain point on a pillar of the church. This pillar thus became the victim of some brutal excavations, and was actually completely ripped open at the level at which she appeared to be looking – the work of overzealous treasure seekers.

A Latin phrase formerly accompanied the bas relief: "Jésu Mèdela Vulnérum + Spes Una Poenitentium + Per Magdalenae Lacrymas + Peccata Nostra Dilius" with three letters "e" decked with accents, as is customary in Church Latin, the form of Latin with which Saunière was familiar – and used in his church.

Many have travelled into the various possible interpretations of the bas-relief and the inscription, but my voyage was into a real landscape, not an imaginary one. It led me to the Pilat, a mountainous region, part of the Massif Central, between St Etienne and Vienne. Mount Pilat is the Northeast point of the Cévennes mountain chain and has a height of 1434 metres. The region is bounded by two rivers, the Rhône to the east and the Gier in the north. In the old days, it was a wild and deserted region, a land of legends, containing many traces of the past, in particular the megalithic era. In the Middle Ages, it was the terrain of a few noble families, who constructed castles, while the monks built their monasteries in the remote valleys. The Carthusian monks, an off-shoot of the Cistercian monks, so intimately linked to the Knights Templar during the 12th Century, were chief amongst the monks arriving in the region, particularly in their monastery of St-Croix-en-Jarez on the northern slope of the mountain. It was to this region that Saunière travelled.

It should be noted that in Saunière's files, as discovered by Antoine Captier, there is evidence that these Carthusian monks donated money to a man, who, on the surface would not feature as a possible candidate for such a donation. Why this money changed hands therefore, is another intriguing oddity of the mystery, unfortunately so far not adequately stressed or researched.

In 870 AD, Gérard de Roussillon, the one who founded the abbey of Vézelay, opposed the king, Charles the Bald. Driven into a corner by the king's army, Gérard left the town of Vienne (Isère) and took refuge in a nearby fortress, probably in the Pilat. But in the end, he surrendered to the king, who allowed him go into exile. In the 11th Century, the Roussillons appeared on their lands at Pilat. They were fervent supporters of the cult of Mary Magdalene. As a result, a Saint Magdalene chapel, which belonged to their fief of Châteauneuf, near Rive de Gier, was built. The chapel was said to possess the relics of St Lazarus, the brother of Mary Magdalene, the man resurrected by Jesus. French legends had it that Lazarus was among the party that disembarked in France with Mary Magdalene.

There are several chronicles about the Roussillon family. Many writers, like Vacher, Francus, J. Batia and Dullac have written about the origins of this family, which was in the Roussillon area, i.e. the village of Ruscino, near Perpignan. Ruscino was once on the sea shore, but has since been ruined by the action of that sea.

Ruscino was built on a Celtic site, dating from 400 BC, occupied by a tribe called the Volques. It became a Roman colony in 120 BC. Ruscino reached its greatest splendour under the rule of Augustus. It was situated on the Roman Via Domitia, the oldest road constructed in Gallia by the Romans. It extends for about 200 km from Rodano to the Pirenei, linking settlements such as Beziers (Baeterae), Narbonne (Narbo) and Salses (Salsulae). Ruscino is one of the most important archaeological sites in recent history. In Roman times, it was situated in a strategic position at the end of the plateau that dominates the valley of the river Têt, from which the Pyrenees are visible.

Near Perpignan, there is still a Château Roussillon, near a place on the sea called "Mas de la Madeleine", to the east of Perpignan. Their name would eventually be given to the entire region, now often referred to as the Languedoc-Roussillon. The emblem of the Roussillons of Châteauneuf was identical to that of the Roussillons in this area, which at that time was part of Catalonia.

In the 13th Century, Guillaume de Roussillon, the Lord of Châteauneuf, was not only the head of large ranges of land, he was chosen to be the

53

The charterhouse of the Carthusians of St Croix en Jarez

sole leader of the support army to defend, together with the Knights Templar's Grand Master Guillaume de Beaujeu, St Jean d'Acre. It was a leadership secretly coveted by several lords, but it was de Roussillon who received the honour. Amongst those reporting to him during this crusade were the Lords of Perillos.

Guillaume de Roussillon died during the defence of St Jean d'Acre, as so many others would also. His widow, Béatrix, inherited the manor in Châteauneuf, which she soon abandoned, to follow, it seems, in the footsteps of Mary Magdalene, that saint so close to her husband's family heart. Shortly after her husband's death, her prayers were answered one night when she dreamed of a luminous cross, surrounded by stars. The following morning she left on horseback to travel across the mountains. The vision manifested itself again, but this time while she was awake: she saw a luminous cross surrounded by stars in the sky, which guided her, until she reached a place where she founded the Carthusian monastery of Saint-Croix-en-Jarez. She obtained permission to end her days there, in a small house next to the monastery, like Mary Magdalene did in a cave. Like Mary Magdalene, she lived alone, like a hermit, only speaking to some of monks, but never allowing herself to see any of them. And whereas Mary Magdalene was entertained daily by the chants of an angelic choir, so did Béatrix hear the songs of the monks... those servants of God, whom she herself could never see, but only hear singing.

In the medieval acts relating to the foundation of the monastery of St Croix-en-Jarez, Béatrix de Roussillon, details how she relied on the advice of her family from the Roussillon, in the Perpignan region.

Saunière placed two inscriptions at the entrance of his church: "In hoc signo vinces", by – or in – this sign you will conquer and "lumen in coelo", light in the sky. The first relates to Emperor Constantine, who saw the apparition of a luminous cross. The second relates to Pope Leo

XIII, whose coat of arms was adorned with a star. The luminous cross and the stars... another coincidence? Or an allusion to Béatrix de Roussillon?

But back to Lazarus. It is in the 11th Century, in a document related to Vézelay and Mary Magdalene, that the first written record can be found of the connection between Lazarus and the voyage of Mary Magdalene to France. St Lazarus was reputedly the first bishop of Marseilles. According to Lion Clugnet, "according to a series of traditions combined at different epochs, the members of the family at Bethany, the friends of Christ, together with some holy women and others of His disciples, were put out to sea by the Jews hostile to Christianity in a vessel without sails, oars, or helm, and after a miraculous voyage landed in Provence at a place called today the Saintes-Maries. It is related that there they separated to go and preach the Gospel in different parts of the Southeast of Gaul. Lazarus allegedly went to Marseilles, and, having converted a number of its inhabitants to Christianity, became their first pastor. During the first persecution under Nero he hid himself in a crypt, over which the celebrated Abbey of St.-Victor was constructed in the fifth century. In this same crypt he was interred, when he shed his blood for the faith. During the new persecution of Domitian, he was cast into prison and beheaded in a place that is believed to be identical with a cave beneath the prison of Saint-Lazare. Late on, his body was moved to Autun, and buried in the cathedral of that town. But the inhabitants of Marseilles claim to be in possession of his head, which they still venerate."

Founded as Augustodunum by the Romans in 14 BC, as the capital for a Roman province, Autun is one of the oldest towns or cities in both Burgundy and France. It was at the end of the 11th Century that the construction of a Romanesque Cathedral, to house the sacred relics of Lazarus, began. It is known that the builders of this Cathedral were heavily influenced by the Basilica of Saint Magdalene at Vézelay, which was under construction at the same time, and only a few miles away.

But it seems it is neither Vézelay nor St Baume, but to Marseilles we need to be looking to find traces of Mary Magdalene. The Berne-manuscript *Vita erremitica* contains the following citation, dating from the 12th Century: "Her cave where she lived for thirty solitary years is said to be found in the bishopric of Marseilles, not far from the Hermitage of Montrieux." Montrieux is a Carthusian house founded in 1117 on the grounds of St Victor de Marseille. In the 11th Century, the old Abbey was under the vocation of St Victor and St Lazarus. And in 1252, the main altar of the building was consecrated with the relics of St Lazarus, St Mary Magdalene and St Anne, the mother of the Virgin Mary. To this day, Carthusian monks still hold the religious services in the cave. Note

that it was in 1265 that the relics of Mary Magdalene allegedly surfaced. So, there is a strange coincidence here: Marseilles, claiming both Lazarus and his sister, Mary Magdalene, and the link between the Carthusian monks there, and in St Croix en Jarez, plus the connection to the Roussillon family.

Who were these Carthusian monks? The name "Carthusian" is derived from the French chartreuse through the Latin *cartusia*, of which the English "charterhouse" is a corruption. The order was founded by St. Bruno, who was born at Cologne about 1030 and died on October 6, 1101.

St. Bruno first had the idea to leave his normal religious life and retire to a monastery was when he met an eminent hermit, St. Robert. In 1075, St Robert had settled at Molesme, in the Diocese of Langres, together with a band of other hermits, who were to form the Cistercian Order in 1098. To quote Ambrose Mougel in the *Catholic Encyclopedia*: "But he soon found that this was not his vocation, and after a short sojourn at Sèche-Fontaine near Molesme, he left two of his companions, Peter and Lambert, and betook himself with six others to Hugh of Châteauneuf, Bishop of Grenoble, and, according to some authors, one of his pupils." He continues: "The bishop, to whom God had shown these men in a dream, under the image of seven stars, conducted and installed them (1084) in a wild spot on the Alps of Dauphiné named *Chartreuse*, about four leagues from Grenoble, in the midst of precipitous rocks and mountains almost always covered with snow."

Their monastery at St Croix en Jarez is without doubt one of their more important centres. The monks were chased away during the Revolution, but in 1896, five years after Saunière's discovery of the parchments, some painted murals were discovered in their former monastery. It was learned that these dated back to the 14th Century. One of them showed the peculiarity of Jesus crucified on a cross… of badly trimmed green wood. It is rare to have the crucifix depicted in wood other than that worked on by a carpenter. Coincidence that such a similar type of wood is found in a painting ordered by Saunière in the church of Rennes-le-Château? Perhaps. At the foot of the cross are the "holy women", including Mary Magdalene, who looks towards Jesus for one last time. At the very bottom of the cross, a cup collects the blood of Christ… imagery of the Grail, at that time, i.e. the 14th Century, already circulating in the courts and convents of Europe. On the other side of the cross stands John the Evangelist, holding a closed book.

Did Guillaume de Roussillon leave certain material concerning Mary Magdalene in the keeping of his wife, and did this find its way in the hands of the Carthusian monks of St Croix en Jarez?

56

Who knows, but what is known is that, in the 17th Century, an enigmatic prior intervened in the history of the monastery. Dom Polycarpe de la Rivière was a scholar and the author of numerous works.

Polycarpe was trained with the Urfé, in Usson castle, the residence of Marguerite de Valois, who was staying there for her own safety. Soon afterwards, the young Polycarpe wanted to live a religious life, which he did on May 1, 1609, in the Carthusian order. But it was beforehand, at Usson castle between 1586 and 1605, that he would meet Beaudoin Brantome, Savaron, Séguier, Magnard and Scaliger... the latter a famous astronomer and the teacher and comrade of that famous "prophet" Nostradamus. In fact, Nostradamus himself, as well as the famous Rabelais, would stay at the castle. All of the other people he met were historical philosophers of the 17th Century, interested in social movement on esoteric, archaeological, heraldic and magical levels. All of them were close to the court of France as well.

At Usson Castle, Polycarpe also met the architect Philibert Delorme, a friend of Nicolas Poussin and Charles Perrault, who made alterations to the Lupé castle, at a time when Polycarpe was changing the lay-out of the monastery of St Croix en Jarez.

A number of Polycarpe's manuscripts speak of a mysterious treasure and one concludes with a phrase in the guise of a caution: "Rendez au roi Denys le Thresor d'or que vous avez trove", "Render unto King Denys the treasure you have found." "Rendez au Roi" or, in Latin, "Reddis Regis", the inscription on the Hautpoul tomb, placed in Rennes-le-Château. Coincidence?

As prior, Polycarpe ordered extensive excavations at Saint Croix and discovered a deposit that was said to be spiritual rather than material. As a result, he was appointed prior of the Carthusian monastery at Bordeaux, then at Bompas, in the area near Avignon. There he began writing up a detailed account of the history of the Church in the Avignon region, including the diocese of Aix-en-Provence, one of whose dependencies was Sainte Baume, with the Magdalene cave. Bizarrely, the work was prohibited by the Vatican. One can only wonder whether Polycarpe perhaps possessed particular information about Mary Magdalene that the Church preferred to lie dormant, rather than be available in the public domain. We do know he wrote a book about Mary Magdalene and the Seven Sleepers of Ephesus, a work that can no longer be found. After his troubles with the Vatican, Polycarpe abandoned Bompas and wandered... literally into oblivion, for it is unknown where or when he died.

No man is an island, and neither was Polycarpe. Polycarpe de la Rivière belonged to the so-called "Society of Angels", or the "Angelical

Society", to which also belonged, at the same time, one Nicolas Poussin, the French artist who had painted *The Shepherds of Arcadia*, as well as Reynaud Levieux, the creator of the Pavillon-painting, in Arques.

There is one interesting, possible link between this society and a murder two centuries later. Abbé Gélis, of Coustaussa, which lies between the Rennes-le-Château of Saunière and the Rennes-les-Bains of Boudet, was assassinated. No culprit was found, but the assassin did leave a clue: the inscription "Viva Angelina". "Long Live the Little Angel"?

Gélis' tomb is decorated with a stylised rose with a cross in its centre. Opposite Pilat is a village, Saint-Andéol-le-Château, where the Carthusians of Saint Croix had several possessions. An identical symbol of a rose with a cross in its centre can be found on an anonymous tomb in the cemetery. It was here that a writer, S.U. Zanne, wrote a strange manuscript about angels. The book is almost impossible to find and has no legal deposition. There is, however, a copy in a library that also holds the works of Polycarpe. Coincidence?

The Roussillon family was not the only noble family in the region. Another family was the Lupé family, with an interesting parallel to the mystery of Rennes-le-Château. Baigent, Lincoln and Leigh claim that Saunière's fortune began to change when he discovered a document from 1244, signed by Queen Blanche de Castille, confirming that the Hautpoul family were descendants of the Merovingian dynasty. This document, if genuine, would be identical to the charter of Alaon, dating from 845 AD, recognising a Merovingian origin of several French families. Though the Merovingian dynasty died with Dagobert I, his brother, Caribert, did have children. Among his descendants were such families as the Montesquiou, the Gaillard, the Comminges, the Gramont and the Lupé family. Today it is known that this document was a forgery, but it was believed to be genuine at the end of the 19th Century.

Furthermore, it seems likely that the Lupé family were indeed descendants of the Merovingians. The oldest official document naming the Lupé family goes back to 662 or 665 AD. A copy can be found in the writings of J.M. de la Mure in 1674. It is addressed by the Archbishop of Lyons, St Ennemont, and was sent to Valdebert, lord of Lupé, the latter being referred to as a cousin to the king and princes, who at that time were Merovingian. The name Lupé is possibly derived from the Latin *lupus*, wolf. It can be found in several place-names under the family's control: Lupoinum and the Villam Lupoicum. De La Mure writes that the Lupé territories were considered to be a principality, which meant that Valdebert had the privilege, and the means, to raise an army that could be equal to that of the king. The family at that time also claimed descent from

The Luppé castle in the Pilat region, home to a family claiming to descend from the Merovingian royalty

Meroveus, the founder of the Merovingian dynasty. This would not be surprising, as the king was considered to be their cousin.

There are only two places in France bearing the Lupé name: one is Luppé in the Gers-region, from which they originated. These Lupé's of Armagnac had another family branch that resided in Lupé in the Pilat. If Saunière was looking for more descendants of the Merovingian kings, as seems possible, given that the Hautpouls were allegedly named such descendants in the parchments he discovered, then his research might have lead him to this Lupé family – and this region.

Access to the town of Lupé is through the village of Malleval, where one can still see the strange tomb of a "Dame Loup" in the cemetery in front of the church. Inside the church is a statue of Anthony of Padua, and a Sainte Germaine, identical to those placed in the church of Rennes-le-Château by Saunière. Saint Germaine originated from the Languedoc, so his presence in Rennes-le-Château is logical; it is less so in the Pilat.

The Lupé family, as could be expected, also had a castle. It was in the 10th Century that the De Falatier family came into the possession of the Lupé estates, which meant that Malleval and Lupé were united under the same ruler. It was during this time that the Lupé castle took its present form. One author, G.M. de Waldan, stated that the towers and turrets were placed in accordance with the outline of the constellation of the Great Bear, with the principal axis directed to the Pole-star. There are

59

underground chambers underneath the Lupé castle. Rumours have it that these once held the remains of Mary Magdalene. My personal investigation into this showed that if they ever were there, they were definitely there no longer. But it is also known that after the Second World War, Antoine Pinay, at that time a future Prime Minister of France, invited an Egyptologist to come to the castle. The purpose of this visit is, of course, unknown.

In 1274, it was this Lupé castle that was the background for a meeting of the Pope, the French king, the Archbishop of Lyons and the Archbishop of Vienne. No-one knows the purpose of this meeting, making it intriguing, to say the least. Afterwards, Lord Guigue de Falatier and his sons were amongst the troops lead by Guillaume de Roussillon that set course to St Jean d'Acre. Only Guigue would return from this suicide mission and therefore the estates passed to the De Gaste family, by marriage arrangements. This is the family that would later marry into the de Joyeuse family, to own Arques. But probably the most remarkable aspect of this family is the transaction of Guillaume de Gaste at Puy en Velay with the Knights Templar of Marhlette, in 1339, more than twenty years after the order had officially been suspended by the Council of Vienne in 1312. One can only wonder whether that meeting in 1274 was related to the demise of the Knights Templar in 1307, when the French king arrested the soldier monks, who were responsible only to the authority of the Pope, Knights Templar who were very prominent in Lyons...

And then it is time for those good old coincidences... if that is what they are, of course. From the marriage of Claude and Francoise de Gaste de Lupé-de Joyeuse, four children were born. One of them, Marguerite de Gaste de Lupé, was the inspiration for Honoré d'Urfé who wrote l'Astrée, which was the book that inspired Poussin to stay in the Forez-region.

But it gets weirder: on December 19, 1598, Catherine de Meuillon, the Lady de Lupé, marries Rostaing de la Baume, Comte de Suze. She arranges with Dom Polycarpe de la Rivière, the prior of St Croix en Jarez, the purchase of the "Fief Lacombe", for which she paid in gold. There, she will open a lead mine, where the workers are imported from Germany. This is shown in the statements of Blumenstein, who was charged with an estimate of the mines in Carthusian possession, in 1741. The mine was called "The Wolf's Hole". When she bought the mine, she said "the time of the wolves is near and the wolf cubs are in the country..." What "time" was she referring to? And did that time have anything to do with the "restoration of a certain King Denys" and a "treasure" about which Polycarpe wrote?

But let us continue our walk through the Pilat. From the village of Malleval, an old path leads to Pélussin. Perhaps a strange question, but did Saunière walk this path?

One path leads to the Château of Virieu. Its tower bears a very strong resemblance to the Tour Magdala on Saunière's estate in Rennes-le-Château. In fact, both are virtually identical. Another coincidence?

Another path from Pélussin climbs up the mountain. A chapel appears, dedicated to St Anthony the Hermit. Inside there is a statue of the saint, almost identical to the one at Rennes-le-Château. It is becoming slightly remarkable to find identical saints in Rennes-le-Château and on this path, in a remote region, hundreds of miles away. Climbing upwards, the path reaches the "wolf's truce". In this deserted wilderness rests another chapel, dedicated to Saint Mary Magdalene. Another coincidence? Probably not when one discovers that inside is the exact replica of the bas-relief in the church of Rennes-le-Château. The saint is at prayer in a grotto, on her knees and with her hands crossed, in front of a cross made from branches of green wood, badly trimmed, bound with a knot. In front of her: a jar of perfume, a human skull and an open book. But even more astonishing is the landscape visible through the opening of the grotto, where one can distinguish the two summits most characteristic of the Pilat: le Pic des Trois Dents and le Crêt de l'Oeillon. This mountain is shown with the cross that marks its summit, a feature that was erected in 1867. This detail allows the dating of the picture, which must have been made after that date. Did Saunière come to this chapel and copy the picture and/or use it as a template, the model for his bas-relief at Rennes-le-Château? The answer seems quite likely to be "yes".

In early 2001, this chapel of Mary Magdalene was pillaged, the burglars entering through the roof. Everything was thrown about, but only one item was taken: the painting of the Magdalene that I believe served as the inspiration for that of Saunière in the church of Rennes-le-Château. Many other precious items were left behind. At the very least a strange burglary, for the painting does not have any real value of its own...

Around the same time in the spring of 2001, a fortified house on the route from Lupé towards the Magdalene chapel was... destroyed by explosives. Without drawing any conclusions I had gone into quite some detail on this house in a French publication. All carvings of an angel and of a crucifix with some interesting symbols were therefore destroyed. Not bad for "doing away with the evidence".

Comparison between the tower of the castle of Virieu (left), near Pelussin in the Pilat, which inspired the Tour Magdala (right)

What can be seen in the landscape of the bas-relief in the church of Rennes-le-Château? A path winding its way through the countryside, then crossing a hill by a door or portico surmounted by three teeth; nearby there seem to be the remains of an arcade in the form of a column and some ruins. The principal elements are a door, a column and three teeth. Intriguingly, door in Celtic is *Pyla*, and column in Latin is *Pila*. Another coincidence? The three teeth can be linked to the Pic de Trois Dents of the Pilat region.

Perhaps Saunière was the state of mind of the traveller who, when at home, wants to be reminded of the voyages he has made. And he echoed these in details of his estate, in decorations, etc. He did not leave clues for others, he left them for himself, to be reminded... of an area he knew of, but did not live in.

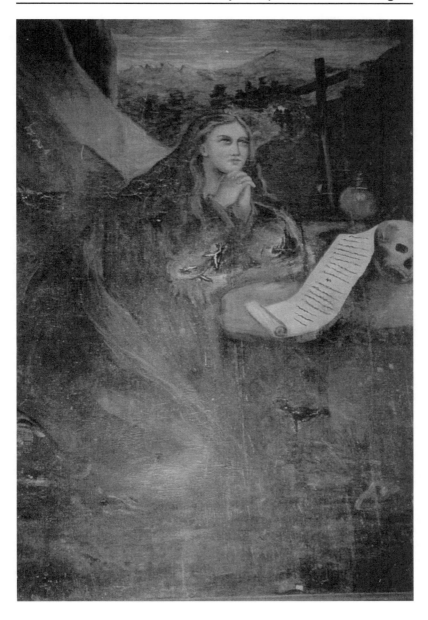

This picture in the Saint Madeleine chapel at Pilat resembles the bas-relief in the church at Rennes in intimate detail.

The Pilat connection has not been mentioned by any of the numerous authors who have worked on Rennes-le-Château, save one, Jean Markale. He wrote: "The key, the famous key which allows access to the accursed gold of Rennes-le-Château, will be found there, in the grotto where La Madeleine is kneeling, and which is not the legendary grotto of Sainte Baume but a symbolic representation in which every point is determined by the priest of Rennes-le-Château."

In Chapter II of his book, he writes about the village of Le Bézu near Rennes-le-Château, where his reasoning leads him to jump from the Razès to the Pilat region. "The name of Bézu is extremely well-known in the land previously occupied by the Celts... In Wales it appears frequently in

Painting from the St Croix en Jarez, discovered in 1896

its form of Bedd... It means both "birch tree" and "tomb". The latter is the usual meaning in Wales at present, where one can see the remains of a dolmen called Bedd Taliesin... A local tradition has it that if one sleeps on top of this dolmen one will wake up either a poet or mad. The same tradition exists in the Massif Central, in the Pilat, in relation to the so-called "roche de Merlin", Merlin's Rock." Alhough this tradition is extremely local, somehow Markale was aware of a local legend known very close to the monastery of St Croix.

Did Saunière leave, at the very centre of his church, a reminder, a key? A key to the Pilat region, where the Roussillon family, with Guillaume and his widow Béatrix, might have possessed specific information about the relics of Mary Magdalene? Where Dom Polycarpe de la Rivière wrote manuscripts on that saint, and was working on more, when the church forbade any further writing.

So did Saunière walk up the mountains from the village of Lupé? Did he come to Sainte Croix? There is at present no hard proof of his travels in this region... but there are definitely more than enough clues... though the evidence is not found in the Pilat, it is in the nearest big town, Lyons.

Chapter 6
Esoteric wanderings in the streets of Lyons

To house his library, Saunière built the Tour Magdala, at the edge of his estate. It has become the best known "photographic billboard" of his mystery. Noel Corbu and Antoine Captier had this to say about the fate of Saunière's library:

"Although the library still has a number of books on its shelves, it is certain that the most valuable of them disappeared a long time ago. The remaining works are on religious subjects like: *L'histoire de la vie des Saints*, the Works of Lacordaire, the *Scripturae Sacrae* of Migne in 28 volumes, the Holy Bible in 20 volumes, edition of 1769, Biblia Sacra of 1710, Sermons of père Bourdaloue, 'Littérature Sacrée' of Genoude, etc. Among the rare novels, some titles are: '*Cinq semaines en ballon*' (ed. Hetzel), '*Souvenirs de la guerre de Crimée*', '*La dame Noire de Myans*' (chronicle of the 13th Century), '*De Paris au Brésil par terre*', '*Expédition Rodger: 'A la recherche de la Jeannette*'', '*Les Héritiers de Judas*', etc.

Concerning the sciences, the history and the geography, we note: '*Géographie Universelle*' of Malte Brun, '*Rome, ses églises et ses monuments*', '*Trois Histoires de France*' by Théodore Burette, Amédée Gabourd and Orusand, '*Histoire de la Nouvelle Hérésie*', '*Le socialisme contemporain jusqu'en 1894*', the 68 volumes of the '*Dictionnaire de la Conversation*', etc.

The abbé Saunière also had a number of bound journals of the period: '*Le Petit Journal*' (an illustrated supplement), '*Le Pélerin*', '*La Vie Illustrée*', '*L'illustration*', '*Le Noel*', '*Lecture pour tous*', '*Le mois littéraire et pittoresque*', etc. Finally many breviaries, books of prayer and collections of canticles ornamenting the shelves of the library, while journals of all kinds were piled up in the wall cupboards. We have looked through each of his books page by page, but we have not discovered any sign or particular note that the abbé could have inserted in them."

Bérenger Saunière's library may have been interesting and of an excellent standard, but it was neither unique of its kind nor an invaluable reference source to the point of being catalogued and sought after by all the book professionals. Interestingly, we know that after his death, a certain part of Saunière's library was bought by two Lyonnaise bookshops, Gacon and Derain-Raclet, at that time in the rue Bossuet. These people acquired these books before Marie sold the estate to Corbu.

I was personally able to examine these books. Of the works recovered at Derain of Lyons, on one particular page of each book (always the same one, at least for the books I have found) there is a capital letter, a number, the signature of Bérenger Saunière and "BS" interlaced around a kind of rising cross. Each time, it is written with a pen, not as a stamp. The books also show the owner: "Francois Bérenger Saunière Prêtre à Aude, ville de Rennes-le-Château." Three books were discovered:

- La Prophétie des Papes attribuée à S. Malachie (The Papal Prophecy attributed to St Malachy) by abbé Joseph Maitre;
- Histoire des Grandes Forêts de la Gaule et de l'Ancienne France (History of the Great Forests of Gaul and Ancient France) by L.F. Alfred Maury;
- Monuments celtiques. Ou Recherches sur le Culte des Pierres. Précédées d'une notice sur les Celtes et sur les Druides, et suivies d'étymologies celtiques (Celtic Monuments. Or Researches on the Cult of the Stones. Preceded by a note on the Celts and the Druids and followed by Celtic etymology), by M. Camby.

How did Saunière's books end up in Lyons? Saunière's relative notoriety was local to Rennes-le-Château and surrounding villages. He was totally unknown to the public at large and therefore, it would seem, to Lyonnaise book-dealers. How did this priest come to the attention of these people? The answer is that Saunière visited the city on numerous

occasions. This discovery is an entirely new angle to the mystery of the village priest. Not only that, though: it is also known that Derain, the owner of the library, frequented "esoteric circles" in Lyons, particularly those of the Martinist Lodge, a lodge also visited by none other than Saunière himself.

Lyons was the capital of Gaul, the Lugdunum of the Romans. It was also the esoteric capital of France, with labyrinths below the ground, ancient catacombs, etc. It is said that one could walk through the city using these subterranean routes, rather than the streets above. It was in Lyons,

which houses the Cathedral of St John the Baptist, where on November 14, 1305, Bertrand de Got was crowned Pope, taking the name of Clement V. It was on the outskirts of Lyons where large numbers of Templars, who occupied the area, were never arrested two years later, as they were unusually absent from their Templar preceptories, when Nogaret made his arrests on order of the French king. The Templar area of Lyons, called Clos de St Georges, was larger than the Temple of Paris. At one time, Lyons was the financial capital of France, was almost the political capital of France, and hence also had a large population of foreigners, including Jews, who were mostly located in the "Quartier St Paul". In 1621, Severt wrote how the Jews were chased from the city of Lyons on July 22, 1311, the feast-day of Mary Magdalene. Many more Jewish persecutions were to follow, each time followed by rumours of how they had left large amounts of money and important jewelry lying about: being bankers and jewellers at the same time, it is clear that each persecution had a monetary aspect to it – and the goal of the persecution was the money that was left behind.

There are two interesting houses in the rue de la Juiverie, "the Jewish Street". Number 21 was designed and decorated by one Philibert Delorme. This renowned architect had constructed the castle of Falaises, and we have come across him earlier, as the architect of the castle of the Lupé family. In the archives of the city of Lyons one can find the old maps of number 21, showing the existence of three subterranean levels. The lowest level opens out into galleries that go below the river Saone, to the old Templar quarters, and then onwards in the direction of the old church of Ainay.

One local legend claims that an important treasure trove was located at house number 23, rue de la Juiverie. It is claimed that a gigantic diamond, said to have been treasured by the French queen Catherine de Medici and her son Francis I, was found behind one of the two lions' heads, decorating the exterior of the house. However, it is known that the house dates from the 17th Century, postdating the reign of Francis I. Catherine de Medici consulted with many astrologers, one of them being Nostradamus. Some chronicles suggest that Nostradamus had access to certain documents, old books, in the rue de la Juiverie, and that these allowed him to write his famous "centuries". It is known that Nostradamus came to Lyons on several occasions. In 1547, he tried to control an outbreak of the plague, together with the writer Francois Rabelais, the author of *Gargantua*. Remember that both stayed in the Usson Castle, where Polycarpe de la Rivière would be educated. Rabelais was a member of an esoteric society called Agla (the initials of the Hebrew words Aieth, Kadol, Leolam and Adonai), which originated from another association, Angelique, the "Society of Angels", to which Polycarpe would also belong.

69

Some of the writings of these Martinist lodges, which according to some stemmed from this "Society of Angels", speak of a resurgence of Agla. What might this treasure have been? When Bertrand de Got was crowned Pope Clement V, the inaugural procession was dramatically interrupted when, only a few metres from the Cathedral of St John the Baptist, a wall collapsed under the weight of the people watching the procession. The king, Philip le Bel, was slightly injured, some members of the papal entourage and royal family died, but the pope, though fallen, was not injured. The papal tiara which fell from his head was found soon after, but its largest diamond, said to be worth 6000 florins, was lost. Was this the diamond later claimed to be linked to house number 23?

Did Saunière visit this house or walk this street? Strange as it may seem, the answer would appear to be "yes". It was a Lyonnaise collector of old papers, Laurent Brannant, who brought a number of documents relating to the Rennes-le-Château affair to my notice. Remarkably, these papers were not all addressed to his residence in Rennes-le-Château, but instead were addressed to a house in the rue des Macchabées, in Lyons! Indeed, Saunière had correspondence addressed to him to a house in Lyons.

This was not just "any" street in Lyons and it seems clear that Saunière specifically wanted to rent a house in this specific street.

It was a street where all those historic people we have previously come across, i.e. Rabelais, the writer and colleague of Nostradamus, as well as Polycarpe de la Rivière, were members of a group called "Gouliard", who were situated in the rue de Boeuf and the rue des Macchabées. Coincidence yet again?

The Gouliards were a secret society with roots dating back to the 9th Century, that practised the so-called "Language of Birds", which is known to have been used by such writers as Rabelais, Charles Perrault and others. The "Sons of Goulia" as they were sometimes referred to, had an perpetual adoration for the Apocalypse of John, but at the same time, they denounced the divinity of Christ, a heresy the Church seemed to indulge rather than act against, as they did in the case of the Cathars. In medieval times, the area of the Macchabees in Lyons was under the patronage of Mary Magdalene. There was a chapel there, as well as a cemetery for 10,000 martyrs, the memorial of which was again under the protection of Mary Magdalene. Only two steps away from Saunière's lodgings was the entrance to an underground gallery, the old catacombs and crypts of Mary Magdalene below St Just. We verified these details ourselves. If Saunière's choice of lodging was completely accidental, then he had a very bizarre "coincidental luck".

Another dimension of his life and doings in Lyons is that it was not secret to other people in Lyons. In fact, it seems that it was only in Lyons that the "true" Saunière surfaced. There is a document, authenticated by a notary, showing that Saunière attended meetings of a Martinist lodge in this city, at least once, on May 11, 1900. His lodgings in Lyons were two doors away from Joanny Bricaud, a prominent Martinist. However, both houses were also connected via an underground passage.

So what is Martinism? The movement originated in the 18th Century, with Martines de Pasqually, a Portuguese Jew. Martinism promoted contact with the spirit world, the desire to reconnect with the "divine self" and also promoted a new cosmogony based around Jesus Christ, with touches of various belief systems, including the Jewish Kaballah.

At the time of Saunière's visit, the movement was lead by "Papus", the pseudonym of Dr. Gérard Encausse, who promoted a strong emphasis on Revelations, i.e. the same emphasis found with the Gouliards of previous centuries.

After Saunière's death, Joanny Bricaud (February 11, 1881 - February 21, 1934) would become the head of the Rite of Memphis-Misraim, the French O.T.O. (Order of the Eastern Temple) and the Gnostic Church. Being very young at the time he knew Saunière, Bricaud's "career" in these fraternities came mostly after 1920.

Bricaud left his biggest imprint on the Gnostic Church. Its founder was Jules-Benoît Stanislas Doinel du Val-Michel (1842-1903). Doinel was a librarian, a Grand Orient Freemason, an antiquarian, a person who made frequent attempts to communicate with spirits.

In 1901, Fabre des Essarts, Patriarch of the Gnostic Church, consecrated the then twenty-year old Jean "Joanny" Bricaud as Tau Johannes, Bishop of Lyons. Bricaud had been educated in a Roman Catholic seminary, where he had studied for the priesthood, but he renounced his conventional religious pursuits at the age of 16 to pursue mystical occultism. He became involved with the "Eliate Church of Carmel" and the "Work of Mercy" founded in 1839 by Eugéne Vintras (1807-1875), and the "Johannite Church of Primitive Christians," founded in 1803 by the Templar revivalist Bernard-Raymond Fabré-Palaprat (1777-1838). He had met Gerard Encausse (Papus) in 1899 and had already joined his Martinist Order, where Saunière would be attending meetings in 1900 – and therefore must have met Bricaud. Various scenarios are possible: did Saunière and Bricaud know each other before Saunière's arrival in the

city and did Bricaud introduce him to the Martinist Lodge? Or did Saunière try to befriend Bricaud and infiltrate the lodge? Though thousands of documents and material owned by Bricaud are stored in the library of Lyons, it is a mammoth task to find out whether they might contain any clues as to the true relationship between the two men.

In 1907, Bricaud broke from Fabre des Essarts to found his own schismatic branch of the Gnostic Church, the Gnostic Catholic Church. Doinel had been a Martinist, Bricaud was a Martinist, but Fabre des Essarts was not. It was announced as a fusion of the three existing "gnostic" churches of France: Doinel's, Vintras', and Fabré-Palaprat's. In February of 1908, the Episcopal synod of the Gnostic Catholic Church met again and elected Bricaud its patriarch as Tau Jean II.

After Papus' death in 1916, the Martinist Order, and the French sections of the Rites of Memphis and Misraim and the O.T.O. were briefly controlled by Charles Henri Détré (Teder), but when he died in 1918, he was succeeded by Bricaud. Upon his death, Bricaud himself was succeeded by Constant Chevillon (Tau Harmonius), who himself was brutally assassinated by soldiers of Klaus Barbie's occupation forces on March 22, 1944.

This is the story of the Rite of Memphis forward in time, beyond the time of Saunière. But there is another connection with Rennes-le-Château, at the very origins of the Rite.

On April 30, 1815, in Montaubon, the Lodge of the Disciples of Memphis was founded by a group of people that included Gabriel Mathieu Marconis de Nègre. The movement had arisen from the French Primitive Rite of Philadelphians, brought from Egypt by Samuel Honis of Cairo in 1814, with the aid of the other founding members. Apparently, they had discovered a Gnostic-Hermetic survival in Cairo, and it seems, in Lebanon "Druse Masonry" that went back to the operative Masonry of the Templars. They decided to renounce their affiliation to the Grand Lodge of London, and to practice a new Rite which owed nothing to England, resulting in the Rite being branded as "irregular" and providing an insecure future for its adherents. Gabriel's son, Jacques-Etienne Marconis de Nègre (1795-1868), was instrumental in writing down its "official history" in 1838. In it, he wrote how after the death of Jacques de Molay, the Scottish Templars rallied under a new order, protected by their king Robert the Bruce. He claimed it was here that the origins of Scottish freemasonry lay, as well as that of the other masonic rites.

Jacques Etienne Marconis was briefly a "Misraimite", before he revived the Rite of Memphis in 1839. As J.-E. Marconis, ge was expelled from

the Rite of Misraim in Paris in 1833, and the following year at Lyons, under the name of de Nègre.

Gerard de Sède stated that this Marconis de Nègre was related to the de Nègre family from Clat, which was the family home of Marie de Nègre d'Ablis, the wife of Francois d'Hautpoul, lord of Rennes-le-Château, the woman buried in the tomb that would suffer from the hand of Saunière's destruction.

It is in that village that Antoine Bigou, a predecessor from Saunière as village priest of Rennes-le-Château (the person who erected the tombstone of Marie de Nègre d'Ables) had also been the village priest. Saunière had been the village priest of Clat before becoming priest of Rennes-le-Château. Coincidence... or not? Though some researchers doubt de Sède's claim of a relationship between Marconis and Marie de Nègre, it is highly likely that Saunière at some point might also have wondered about whether such a relationship might have existed.

Apart from books, certain other material of Saunière's survived in Lyons – though classified as "old papers", of apparently little value. The lot of "old papers" that were retrieved can be divided in two categories: documents, both printed and hand-written, relating to a symbolic philosophy and others meant especially for affiliates of the Martinist Society. The second category is local correspondence, like short laconic letters relating to this society, six letters received from people living in the Rhone-Alpes region, thirteen various invoices, two of which are for photographic material, very technical for the period and definitely so for a village priest. This category also holds a letter from a goldsmith, a certain Jean Soulier, rue Victor Hugo, in Lyons, and another letter from a dealer in precious stones, a certain D. Coindre, cours Viton, also in Lyons. One can only wonder why a village priest needed the help of these people. Was it perhaps to value certain finds he had made? But it is difficult to discuss these last two letters as we do not have the contents of Saunière's letters that provoked the responses in our possession.

One of the letters he received at his Lyons address came from a correspondent from Montpellier. The subject of these letters is Maguelonne, an island off the coast of Montpellier. Saunière seems to have requested details about discoveries made on the island, as well as an overview of its history. The island was once the Southern version of Mont Saint Michel, the famous French peninsula off the coast of Normandy, hosting an impressive cathedral dedicated to St Peter.

Saunière seemed particularly interested in the discoveries made by De Moutan, who had analysed the origins of the name Maguelonne. De Moutan had stated that the name was connected to Mary Magdalene. According to certain sources, Magalo in the language of the Provence

region would mean Magdalene. Local legends stated that it was on this island that Mary Magdalene came ashore, whereas the rest of her party sailed further on, eventually disembarking in Saintes Marie de la Mere, the traditional disembarking point.

De Moutan wrote about a discovery that occurred in 1812 when local stonecutters discovered a cave, showing clear signs of human habitation, as there were steps leading down into it. Inside, not only did he find certain tools, but also a statue of a woman with hair reaching the ground, holding in one hand a cup and a cylinder in the other hand. De Moutan apparently did not link this statue with the depictions of Mary Magdalene, who was said to be clothed only by her hair, that had reached the length of her body.

A document dating from 1477 claims that Maguelonne was the name of a woman, the daughter of the king of Naples, who became the wife of Peter, Count of the Provence. They eloped, first to Septimania, later to Maguelonne, where the lovers fell asleep on the shore. Peter observed a bird and decided to follow him, thus reaching Egypt, where he befriended a sultan. In France, Maguelonne tried to find her husband, but finally concluded he was most likely dead and therefore founded a hospital in the city that bore her name. Seven years later, Peter returned, but discovered that his wife was now celibate and therefore decided he would only visit her every seven years.

An unbelievable story, but perhaps hinting at something else, for in the language of the Provence, Magalouno means Venus. De Moutan's private collection contains several statues of Venus that he had discovered on the island. If Peter was a substitute for the planet Saturn, then perhaps the seven year cycle would make sense, for Venus and Saturn are in conjunction every seven years.

A suburb of Maguelonne was called Villeneuve-les-Maguelone, which originally was called Ste Marie Magdeleine d'Euxynte, allegedly named after the wife of a Greek colonist from the 4th Century BC.

Maguelone also had a cave, the cave of Magdalene, even though the true name of this cave is "the cave of the Baume". De Moutan believed that this cave previously had several levels and that possibly it even contained buildings.

Did Saunière believe this was the true location of Mary Magdalene's final resting place? One can only wonder… once again. But it is becoming quite clear that Saunière did seem to have a fascination with this woman.

Let us return to the question of whether Saunière visited the Pilat region. The Pilat region is about sixty kilometres from Lyons, so Saunière must have had an independent means of transport adapted to the region, if he went there from Lyons. The invoices, however, speak for themselves.

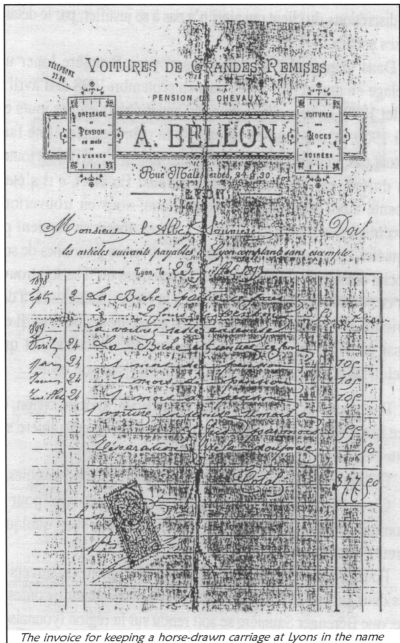

The invoice for keeping a horse-drawn carriage at Lyons in the name of Sauniere (private archives of Laurent Brannant)

They attest to Saunière having access to a local means of transport, fairly speedy for the time, to move from the Lyons area: a horse-drawn vehicle. The invoices show he rented two such vehicles, one used for different purposes from the other, reserved at his disposal for quite long periods of time. The conditions do not say what the vehicles may be used for. The agreement considers that the vehicle "may be used at the discretion of the client", who then does not have to justify the details of his journeys. It seems quite perfect for someone like Saunière who did not want to leave too many trails behind.

According to the first invoice, Saunière hired a horse drawn wagon in May and June 1898, then in September 1898 and finally from April to July 1899. The second invoice is for several days in May 1900 and a day in June of the same year. It was in May 1900 that he attended the Martinist Lodge meeting.

However, this does not mean Saunière was in Lyons all that time. Probably, he was only there for certain periods, perhaps sometimes somewhat longer. But precise dates are impossible to establish now. Perhaps Saunière visited the city more frequently, for it is quite possible these two invoices are not the only invoices that existed – or might exist elsewhere. Too much interpretation based on these documents might therefore introduce errors in the conclusions. But they are undeniable proof of the fact that Saunière was present in Lyons, near the Pilat Massif, and that Saunière was interested in moving around in the countryside, for he hired a horse-drawn vehicle. So he wanted to go somewhere from Lyons. The Pilat seems, in light of the above, the most logical solution.

Did no-one miss Saunière back in Rennes-le-Château? Saunière's records, including his expenses, were discovered upon Marie's death. In *The Heritage of Abbé Saunière*, Claire Corbu and Antoine Captier state how the period between 1898 and 1900 were "quiet years". In 1897, Saunière had finished the redecoration of the church in Rennes-le-Château, and in 1901, he started the plans for his domaine, the Villa Bethania. Those two years were taken up by "a few bills for wine and a large one for window glass, which, as usual, he delayed paying". He did begin to buy up the land around the presbytery in Marie's name, pulling down the ruined cottages and using the stones for his grotto. But it is clear that his primary interest lay elsewhere, and the "Lyons episode" fills in this "quiet" episode of his known and otherwise busy life. It is clear that he kept the Lyons episode strictly separate from his "Rennes-le-Château" life, with most likely only Marie knowing the whereabouts of her master.

Other "Lyons documents" show that Saunière had a strange interest in exotic photographic equipment. Amongst the lot are two letters.

The first is dated July 26, 1899 and comes from a shop called L. Joux, rue Denfert-Rochereau in Paris, and is merely a catalogue with prices of what they have on offer. The second is dated July 29, 1899, from a photographic specialist shop, J. Zion, in Boulevard Richard-Lenoir, also in Paris, and is much more precise, as it answers questions posed by Saunière.

It goes into detail about photographic objectives, not commonly used by amateur photographers. It gives details on "rectilinear objectives". But such material was only used by professionals, people involved in geometry or cartography. There are also details about "long distance binoculars" which seem to be very rare as the photographic shop says they can only provide them after they have ordered them themselves.

Did he use this material for research in the Pilat region? Though possible, the goal seems to be in the Perpignan region, in particular Perillos. To quote the French author Jean-Luc Chaumeil: "The priest made several voyages. His absences lasted about a week each time. We know he spent some time in the Perpignan area, that he came down to the hotel of Eugène Castel, that he took the greatest precaution to make people believe he had not left his parish, particularly by sending to his superiors letters he had composed previously and which his servant [Marie Denarnaud] posted from the village of Couiza during his absence."

This evidence makes it obvious that Saunière's activities in Lyons did not fall into the tourism category or his religious duties to the Catholic Church. They were very private and he wanted to keep them hidden from everyone – or at least most from those he knew. Hence the address in Lyons to which correspondence was sent that he surely did not want to receive in Rennes-le-Château. And secondly, perhaps it was because he did not want to allow the Paris shop to associate him with Rennes-le-Château.

If there was no hidden agenda, it would be strange, for Saunière was not afraid to ask Parisian photographic studios to create postcards of his estate and the countryside. Such requests were done from his villa in Rennes-le-Château. So he could even feign a sudden interest in photography, based on the fact that the photographers came to make those postcards and he became interested himself. But instead he used the Lyons address for the ordering of this equipment, equipment which would disappear later, for there is no trace of it to be found anywhere – nor is it mentioned anywhere, which is, of course, not so strange knowing that Saunière took great pains to make sure no-one knew about it in the first place. It was literally a hidden life, a secret life, of the village priest. But why?

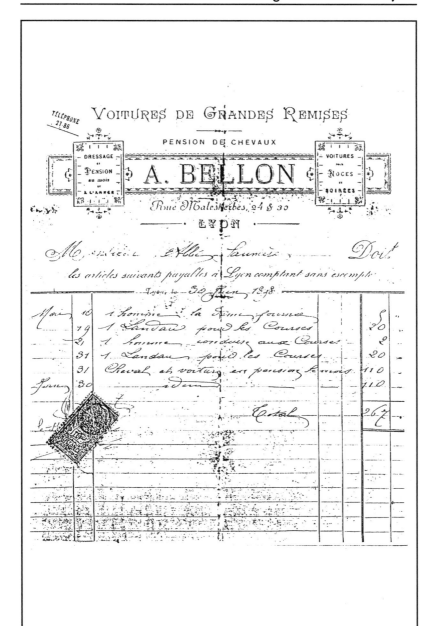

The second invoice from the same firm to Sauniere, addressing rent of the vehicle.

Part III

The model

Chapter 7
The discovery

Somehow, I ended up with a model ordered by Bérenger Saunière, just before his death in 1917. The model was put on sale, by accident, and this is how it came into my possession.

Unfortunately, the circumstances in which I was able to recuperate the model in 1991 are not very interesting. To de-dramatise it, let me state that it was a coincidence, as the seller did not understand what he had on sale or its possible repercussions. Neither did he know who Saunière was, or what the mystery of Rennes-le-Château is. These facts themselves have led to a lack of understanding, as few seem willing to accept that there is no further mystery to this acquisition. There has been speculation that I acquired the object only after a secret deal involving enormous amounts of money, or that I was "ordered" to acquire it on behalf of "secret powers". I have been labelled a member of the Priory of Sion, of Opus Dei, of other, even more esoteric or secret organisations… and some went even further. What I learned from this was that the truthful circumstances can never be conceived of in the minds of many, particularly when the subject contains keywords such as "mystery" and "Rennes-le-Château".

I informed a small number of people about this model in 1992 and I, as well as they, began researching it in more detail from then onwards. Later, I wrote about the model in a magazine article and to my surprise, I learned that no-one had apparently ever heard about the existence of this model, which came to me as a great surprise. Contacts with knowledgeable people such as Antoine and Claire Captier strengthened this observation: no information existed about this model, which was, to say the least, intriguing.

This led to a deluge of questions, as well as a copy of the model being exhibited in the Villa Bethania museum, Saunière's former estate in Rennes-le-Château. It also resulted in endless queries and a lot of hassle from and with various people and other researchers. There were allegations that the model was a fake, some claiming I had forged it, others merely saying that Saunière had "allegedly" ordered it, etc. In short: the usual accusations and rumours that surface whenever a new discovery is made. That I had supporting evidence in the form of letters between Saunière and the model maker, was apparently unknown to those crying forgery – or perhaps it was knowingly not mentioned. But more interesting was to find out that certain people did indeed know about the existence of

this model, but this group of researchers was very discrete and not very communicative. They also possessed documents, letters between Saunière and the model maker, but they were not sure whether the model was ever made, as Saunière was in bad health. They believed the model was either never made or possibly destroyed by the model maker. When I made the existence of the model known to the outside world, for them it answered a lingering question that had never been answered before.

This episode allows the supposition that some information regarding this project of Saunière's was known in certain circles, even though the name of the foundry nor the area in which the work would be carried out was kept secret. It seems we can assume that this original source of information was told by Saunière himself, and that therefore this person, or persons, were one of those people he felt were safe or comfortable to confide in.

Saunière made sure that no-one would discover what he was doing by using a little-known model maker in the region of Aix-en-Provence. And this makes the requirement to establish that Saunière was indeed the owner of this model very important.

At the time of purchase, we also received several documents that were held in an envelope, stuck under the base of the model. Three letters were exchanged between Saunière and the foundry. One letter is a carbon copy of a letter from the foundry sales department pointing out that it specialised in the production of religious objects in bronze. The letter is reproduced on carbon paper, the usual method in a time when copies could not be made any other way. It merely states that they have received Saunière's letter and goes on to reply to that letter, which is not in our possession.

The two letters from Saunière date from 1916. The first speaks about accompanying illustrations and photographs. He asks that the instructions should be carefully followed and to inform him if they have difficulties in creating the model. The illustrations and photographs, however, were no longer with the letter. In the second, of which I have only a partial copy, the priest asks for some final modifications before making the actual casting. These are textual details, very short, only three or four words, that would be engraved on the final model. They were written technically, in a "telegraphic style", only concerned with details on the finished object. He also had some administrative enquiries about payment and delays.

This correspondence implies that one and perhaps several letters or preliminary contacts did exist, because Saunière goes straight into developments on the already existing data on the model. If any

suchpreceding exchanges took place, we have alas no record of them.

In these two letters, Saunière gives topographic information that is needed for the execution of the model. These details are about words and names corresponding to certain real places and the transposition of those on the model. These names were registered on the sketches that resulted from area surveys and they had to be transposed on the model according to Saunière's specific wishes.

An authentic toponomy, known to the priest, found itself being transcribed in a representation with religious connotation, adapted and summarised in the extreme in a mystical aspect of the model... a volume of material summarising the single and ultimate message as intended by Bérenger Saunière.

The model maker, it seems, was unaware of what the model was supposed to resemble. After all, Saunière being a priest, there seemed nothing strange about his order, which has a religious theme, ordered from a company specialising in religious models. Furthermore, at that time, there was no such thing as the "mystery of Rennes-le-Château", and no-one would suspect any hermetic or esoteric aspect to Saunière's actions. Nevertheless, Saunière could have ordered this model from someone in the Toulouse region from where he acquired the statues for his church, but instead he took the precaution of having it done by an obscure artisan in the region of Marseilles.

This desire to put some distance between him and the model maker can be attributed to a desire to be discrete, but perhaps he also feared that an attentive worker, living in or familiar with certain regions of the Corbières and the Roussillon, could easily identify the true location from Saunière's notes and remarks... however carefully shortened they were.

The reproduced excerpt suffices to show that the writing and the signature is that of Saunière and that he was definitely aware of the creation of this model. I cannot reproduce the place names in the first and second letter, as those locations are currently private property. Furthermore, knowing that any publication at present would result in massive search parties by completely unqualified people, I also think it is prudent to withhold this at present. In the mystery of Rennes-le-Château, the mere mention of some treasure has lead to many serious but unfortunate errors, including one recent "excavation" near the water reservoir at the bottom of the village, resulting in the contamination of the water supply to Rennes-le-Château, a situation where the villagers were left without drinking water for several months! Let us therefore

not walk down that treacherous path… but at the same time know that the area and place names will be revealed "by approximation" on the following pages.

After our acquisition, we received another carbon copy found by the person selling us the model. This last letter is a copy of a letter addressed to the priest, enquiring why he is no longer responding or showing any sign of life during the past months. This letter, as well as the first letter, are purely business letters and contain no information on the object to be created or its intended message. It is clear that the foundry did not know that at the time they had sent this letter, Saunière was dead, the result of a heart attack.

These four documents clearly are not the whole of the correspondence between Saunière and the foundry. Even though we do not possess all, it is clear we cannot deny their possible existence. One of the carbon copies is a reply to a letter from Saunière, which is clearly absent from the envelope that was attached to the model. This means that at least one letter is missing. But it seems logical to assume that more letters were exchanged to create this model; it would almost be miraculous if it was accomplished in a mere three letters! It is therefore entirely possible that someone has, or will discover, more letters, unless those missing pieces have been destroyed or lost…

Chapter 8
The model

The model is the final rough cast on which all the written elements and the final modifications as requested by Saunière are found. The object is made in plaster and fixed into a wooden frame. The whole plaster model is dyed so as to simulate bronze. The base girdling the landscape is made of four small wooden planks painted brown.

This "final draft" would then be used to produce a wax master for a single model, as had been requested by the client, Saunière. The end result would have been produced in bronze; it would have had a significant weight and encumbrance – something that would have been of great importance to the client.

The model resembles a "military map in relief", representing a topographical portion of a place with mountains, valleys, paths or river, hollows and one building. The precise dimension in millimetres are: length 1= 600; length 2= 607; width 1= 395 and width 2= 424. The dimensions of the label are 132 by 94 mm. The height of the wooden frame is 55 mm over the whole perimeter. The highest point of the decoration is about 140 mm.

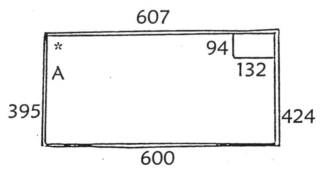

Most interesting is that these dimensions coincide with the dimensions of the tomb of the Lady d'Hautpoul, in the cemetery of Rennes-le-Château, the very tomb made famous by the original creators of the enigma, as well as a tomb that was to suffer the rage of Saunière. Coincidence? It definitely does not seem to be the case. Rather, one would suggest that Saunière carefully measured the dimensions of the tomb, and would later re-use those dimensions for the creation of his model.

There are five inscriptions: GOLGOTHA Mt DU CALVAIRE (Golgotha

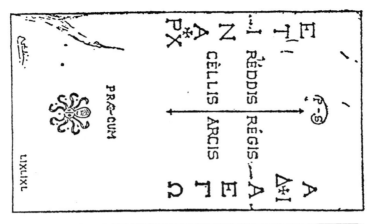

The tombstone and the model of Lady d'Hautpoul have the same dimensions

Mount of the Calvary), JARDIN DE GETHSEMANI (Garden of Gethsemane), TOMBEAU DU CHRIST (Tomb of Christ), TOMBEAU DE JOSEPH D'ARIMATHIE (Tomb of Joseph of Arimathea), CITERNE (water reservoir). The first four inscriptions are in capital letters, the fifth is in small letters and in italic script. In one of his letters, Saunière stated he wanted to modify the geometric direction of the two lone groups of words. Originally written vertically, they are now horizontally.

At the top right hand corner is a label with the titles in printed characters, in a flat hollow made for it:

88

LE CALVAIRE
ET LE SAINT-SEPULCRE

ETAT PRIMITIF

The Calvary
And the Holy Sepulchre

Original State

The text can be interpreted on two levels: "original" also implies an alteration took place later on. On this level, the model represents the "true state" or "truth" of something, before it was changed later, the change making it no longer true or accurate.

Creating the model
Saunière had asked for a model of which only one copy would be made. He had paid the total cost for this before the work started. The casting technique would have been the same as for all other models done by the artisan: a plaster cast was made, which would allow for modifications up until the moment of the bronze casting. From the plaster model, a mould is then created, often consisting of several pieces. This mould is a negative image of the final work, into which the liquid metal will be poured, thus creating the final model, in bronze. Afterwards, the plaster model and the mould would be destroyed, thus ensuring the uniqueness of the finished product. And this was what Saunière would have expected. But it never came to that stage of the process and what I have in my possession is the plaster model, which would have been true to the final product.

This model is the work of a professional model maker and creating such a model would have been no problem whatsoever for the founder. This would mean the base should be perfectly rectangular. But the base is not a rectangle with right angles, but a trapezium. The latter gives us an angular difference of between three and four degrees. It might not be much, but it should be noted that making it a perfect rectangle would no doubt have been easier for this professional firm. All geographic outlines or land surveys carry some indications that allow the user to situate himself in space. Normally, the "base reference" is the direction of terrestrial North, which is mentioned on all

The model

maps we use, even those that have a relief.

However, on this model there appears not the slightest indication of orientation or symbolic direction. Lapse of memory? Probably not. Intention? Probably yes. The variation noted between the (imaginary) right angle and the real angle of the small wooden frame would be superimposed perfectly on the traditional readable variation on each cartographic reference of the Ordnance Survey/I.G.N. with regard to the usual direction of true North.

On each document requiring a precise orientation, North is always indicated by a 'Magnetic' North, as well as by true North, the difference between magnetic and true North being 3,98 degrees. Curiously, we note that using the French I.G.N. maps, the difference between those two Norths corresponds precisely to the declination at the "cartouche side" of the model. It indicates to the reader of the model as to in what direction Saunière wanted us to look at the model.

As mentioned, the final product carried a religious overtone, which would hardly have surprised the model maker, as the customer was a priest. The place names and the title of the model clearly call to mind the area where the Passion of Christ was played out. But there seems to be a mismatch between the topographic reality of the Jerusalem area and the area represented on this model. Furthermore, the nature of the symbolism used in this model is also doubtful. No religious brother, I would think, would have risked committing some flagrant mistakes, like

giving Jesus a different tomb from that of Joseph of Arimathea. We will return to this later.

The information is also lacking any real detail. The style corresponds with little else. It can neither be attributed to a popular fashion or a anything particular. Furthermore, it lacks everything that we would expect to see from Saunière in his usual religious acquisitions and style, as evidenced in Rennes-le-Château.

Furthermore, we cannot conclude that the final product has any harmonious qualities. Aesthetically, it is very controversial; the appearance is to say the least somewhat doubtful, if not even ridiculous. If it has a goal, it is clear it will not leap out at the first glance. But the price, which was very high for this unique and original piece, gives the lie to the possibility that this was a sudden impulse, a prank or a joke, as we know the priest was not one to waste money.

These conclusions suggest that the model contains specific information that only Saunière was able to extract from it quickly and easily... or that a group of other people would, given some additional information, be able to "read" the model. What could this information be? In what form was it presented? For who was it intended after the death of the priest? Or why? What was its true purpose?

Possible hypotheses

The inscriptions on the model name two people, Joseph of Arimathea and Jesus, as well as two locations, Golgotha and Gethsemane. Note that Mary Magdalene is often connected with a skull lying beside her. Tradition has it that the skull of Adam, the first man, was buried underneath the hill of Golgotha, a name meaning "skull". This was also linked with the words of St Paul, who stated: "Jesus is the new Adam and redeemed Mankind by the green wood of the cross." Green wood, also used in Saunière's depiction and the mural in the St Croix monastery in the Pilat region.

The Garden of Gethsemane

On the eve of Good Friday, Jesus went to the Mount of Olives near Jerusalem, with Peter, James and John. It would be there that Jesus would spend his last night. At the foot of the Mount of Olives is a river, the famous Garden of Olives, as well as Gethsemane, which means "Press of Olives". It is here that Jesus told Peter that he would betray him three times before the cock crowed thrice. That prediction would come true and these and similar events would add to the Passion of Christ. From here, everything goes very quickly, ending with Easter... and the Resurrection of Jesus.

Cistern

The word "cistern" is common and therefore difficult to explain. But in the context of the model and its religious representation, it most likely illustrates the place where the wood of the cross of Jesus' torment was found. Tradition says, and it may very well be true, that this cistern became the "Crypt of Saint Helena", the mother of Emperor Constantine, to commemorate her discovery of the True Cross. It seems that before the Passion of Christ, this place was a kind of swimming pool in which the Jews floated wood that was used for the cross of Jesus. Water in this cavity was turbid and was reputed to cure the sick. Two centuries later, Helena would find the three crosses here, two meters under the ground. Saint Helena's discovery of the True Cross occurred in Jerusalem in 335, during the course of excavating the foundation for Constantine's basilica of the Holy Sepulchre on Mount Calvary. The story goes that Helena made a pilgrimage to Jerusalem to walk in the footsteps of her Lord. She wanted to venerate the wood of the Cross, but no one seemed sure of where it was to be found. Helena consulted the local people, who stated that if she could find the sepulchre, she would find the instruments of the punishment, because the Jews had a custom of burying such objects in a hole near the burial place of executed criminals.

When the Empress ordered the temple and pagan statues that had been built on Mount Calvary to be destroyed, they discovered the Holy Sepulchre and the three crosses near it, together with the nails that had pierced Jesus' body, as well as the plaque that hung on the Cross. As the plaque had become detached, they didn't know which was Christ's Cross. Bishop Saint Macarius suggested that the three crosses be taken to the home of a prominent lady who was extremely ill. There he prayed to God and laid each cross in turn to the sick woman. At the touch of one, the woman made an immediate and complete recovery. This was declared to be the True Cross and it is from this cross that all relics, said to be "the true wood of the True Cross", are derived.

Golgotha – Calvary Mount

From a chronological point of view, several items are missing from the model. No mention is made of the palace of Caiphas, to where Jesus is taken upon his arrest. No mention of the Sanhedrin, where Jesus is delivered into the hands of the Roman governor Pontius Pilate. Nearby was the Field of the Potter, which was used as a cemetery for foreigners and today is still called Hakeldama, the Field of Blood. The model also ignores the Palace of Herod Antipas, the final stage of the journey before the ascent of Calvary and Golgotha, even though those two places are inscribed in the decor of the model.

There is one small biblical detail that needs to be mentioned as it is linked to this model. Jesus was too weak to carry the crucifix all along his "calvary" himself because of the flagellation he had received beforehand. It is there that one Simon the Cyrenean was called from the crowds by a Roman centurion, ordering him to help Jesus carry the cross. Finally, after the arduous ascent, Golgotha or the Mount of Calvary is reached. On the ninth hour, i.e. at 3pm, Jesus died. As it was Friday, it was the day before the Jewish Sabbath. And it was on that day that not a single body could remain on the crucifix.

"Therefore, because it was the Preparation Day, that the bodies should not remain on the cross on the Sabbath (for that Sabbath was a high day), the Jews asked Pilate that their legs might be broken, and that they might be taken away. Then the soldiers came and broke the legs of the first and of the other who was crucified with Him. But when they came to Jesus and saw that He was already dead, they did not break His legs. But one of the soldiers pierced His side with a spear, and immediately

blood and water came out. And he who has seen has testified, and his testimony is true; and he knows that he is telling the truth, so that you may believe. For these things were done that the Scripture should be fulfilled, 'Not one of His bones shall be broken.' And again another Scripture says, 'They shall look on Him whom they pierced.'" (John 19, 31-37)

Shortly afterwards, Joseph of Arimathea came to claim the body of Jesus, and Pilate ordered it to be given

Simon the Cyrenean helping Jesus carry the cross

93

to him. "This man went to Pilate and asked for the body of Jesus. Then he took it down, wrapped it in linen, and laid it in a tomb that was hewn out of the rock, where no one had ever lain before." (Luke 23, 53-54)

"After this, Joseph of Arimathea, being a disciple of Jesus, but secretly, for fear of the Jews, asked Pilate that he might take away the body of Jesus; and Pilate gave him permission. So he came and took the body of Jesus. And Nicodemus, who at first came to Jesus by night, also came, bringing a mixture of myrrh and aloes, about a hundred pounds. Then they took the body of Jesus, and bound it in strips of linen with the spices, as the custom of the Jews is to bury. Now in the place where He was crucified there was a garden, and in the garden a new tomb in which no one had yet been laid. So there they laid Jesus, because of the Jews' Preparation Day, for the tomb was nearby." (John 19, 38-42)

"Now after the Sabbath, as the first day of the week began to dawn, Mary Magdalene and the other Mary came to see the tomb. And behold, there was a great earthquake; for an angel of the Lord descended from heaven, and came and rolled back the stone from the door, and sat on it. His countenance was like lightning, and his clothing as white as snow. And the guards shook for fear of him, and became like dead men. But the angel answered and said to the women, "Do not be afraid, for I know that you seek Jesus who was crucified. He is not here; for He is risen, as He said. Come, see the place where the Lord lay. And go quickly and tell His disciples that He is risen from the dead, and indeed He is going before you into Galilee; there you will see Him. Behold, I have told you." (Matthew 28, 1-7)

"He was still in Galilee, saying, 'The Son of Man must be delivered into the hands of sinful men, and be crucified, and the third day rise again." And they remembered His words. Then they returned from the tomb and told all these things to the eleven and to all the rest. It was Mary Magdalene, Joanna, Mary the mother of James, and the other women with them, who told these things to the apostles. And their words seemed to them like idle tales, and they did not believe them. But Peter arose and ran to the tomb; and stooping down, he saw the linen cloths lying by themselves; and he departed, marvelling to himself at what had happened." (Luke 24, 7-11)

"Now the first day of the week Mary Magdalene went to the tomb early, while it was still dark, and saw that the stone had been taken away from the tomb. Then she ran and came to Simon Peter, and to the other disciple, whom Jesus loved, and said to them, 'They have taken away the Lord out of the tomb, and we do not know where

they have laid Him.' Peter therefore went out, and the other disciple, and were going to the tomb. So they both ran together, and the other disciple outran Peter and came to the tomb first. And he, stooping down and looking in, saw the linen cloths lying there; yet he did not go in. Then Simon Peter came, following him, and went into the tomb; and he saw the linen cloths lying there, and the handkerchief that had been around His head, not lying with the linen cloths, but folded together in a place by itself. Then the other disciple, who came to the tomb first, went in also; and he saw and believed. For as yet they did not know the Scripture, that He must rise again from the dead. Then the disciples went away again to their own homes." (John 20, 1-10)

"But Mary stood outside by the tomb weeping, and as she wept she stooped down and looked into the tomb. And she saw two angels in white sitting, one at the head and the other at the feet, where the body of Jesus had lain. Then they said to her, 'Woman, why are you weeping?' She said to them, 'Because they have taken away my Lord, and I do not know where they have laid Him.' Now when she had said this, she turned around and saw Jesus standing there, and did not know that it was Jesus. Jesus said to her, 'Woman, why are you weeping? Whom are you seeking?' She, supposing Him to be the gardener, said to Him, 'Sir, if You have carried Him away, tell me where You have laid Him, and I will take Him away.' Jesus said to her, 'Mary!' She turned and said to Him, 'Rabboni!' (which is to say, Teacher). Jesus said to her, 'Do not cling to Me, for I have not yet ascended to My Father; but go to My brethren and say to them, 'I am ascending to My Father and your Father, and to My God and your God.' Mary Magdalene came and told the disciples that she had seen the Lord, and that He had spoken these things to her." (John 20, 11-18)

These texts show the importance of the tomb of Joseph of Arimathea in the defining moments of Christianity. Furthermore, it is clear that there is only one tomb involved in these events. At least when one uses the bible as authority for the allegations surrounding the final moments of Jesus the man and the early moments of his existence as the Saviour of Mankind, as Saunière allegedly believed. As far as the Catholic faith and Christianity in general is concerned, there never was a "tomb of Jesus Christ". The only tomb was that of Joseph of Arimathea, intended to be used only by himself, but in the end used to keep the body of the Saviour, from where it would rise.

But on the model there is a "tomb of Joseph of Arimathea" and another tomb, that of Jesus! With that single act, this model has attained an altogether different aspect: heretical, iconoclastic and difficult to understand. Difficult to understand, for the model was ordered and

specified by a man, a priest, who knew his Scriptures. If he was unaware of the precise circumstances regarding the crucifixion from memory, there was always the Way of the Cross in his own church, in fact, a Way of the Cross he ordered himself and whose details themselves have been subjected to various and diverse interpretations.

How can one therefore explain that such a man would allow such a mistake to go through the various proof stages of the model's making without being corrected? No-one with a basic understanding and knowledge of the Gospels would never have made such an error and it is obvious that a man confronted with those writings throughout his life would never make such a mistake.

Did Saunière loose his abilities to think clearly, or did his memory fail him, in those last months of his life? Or was it that he was trying to pass on information that surpasses the imagination? But let us not hurry to any conclusions yet, for we will find later on that this "error" will be repeated, maintained and even amplified by certain religious writings as to what seems to be the mystery of Rennes-le-Château and the secret discovery of Saunière.

Chapter 9
The posthumous message of Saunière

Saunière carefully organised the conception of the model. HHe had an eye for detail and asked for precise modifications. The priest had planned his project with great care. This seems to be in conflict with the nature of the model, which, at first glance, is quite mundane: a geographical setting of the last hours of Jesus, a theme not surprising when a priest asks for its execution. But Saunière excludes certain key details of the events surrounding the last hours of Christ. At the same time, he has introduced certain "errors" regarding those events, such as two tombs instead of one. So can we suppose that this model is not an object born of mockery, from the imagination, but in fact the final message of Saunière, the priest of Rennes-le-Château, used to impart a precise set of informative details regarding a secret he found impossible to reveal in any other format? The particular tree of Saunière's seems to have obscured the entire forest. All researchers have followed details of the life of Saunière that were at best deliberate diversions to discourage them. Every item in the possession of the priest – or linked to him – has been reviewed and examined minutely for interpretation, some extremely esoterically: paintings, statues, Way of the Cross, his works in the church, his property, etc. Others have

digressed into the mystery of the Priory of Sion, a presumed secret society inflated by authors popularising Saunière's mystery.

At the same time, the true, unnameable secret slept peacefully elsewhere, undisturbed, while other aspects of the priest's life were exploited to grotesque proportion. And even though Saunière never saw the final result of this project, in the end he achieved the success he was aiming for.

The details show that the model was without a doubt Saunière's final legacy, his final revelation. What we need to try and understand is that not only did the priest want to give some secret meaning to the object, but also in what form he encoded his message. The model is a geographic representation. And it is certain that the places have a purely religious connotation. The details listed on the model are clear and correspond to famous biblical figures. There are no two ways to interpret it.

The title or an inscription is always the shortest resume of the contents. In this context, it details information about the Calvary and the Holy Sepulchre. And it is clear that those locations encapsulate the events surrounding Easter, the crucifixion of Jesus, his entombment... and his resurrection. These places in the biblical writings only appear at this short, but paramount, dramatic time of the life (if one can say) of 'Jesus'... thus logically of the 'Christ'. On the model, we see the Calvary and the two tombs, one of which is, biblically speaking, the Holy Sepulchre. Those are the spatial details.

In the title, there is only one chronological piece of information, "Etat Primitif", "Original State". This seems to suggest – or leads one to suggest – that there are more "states", and that the attention should go to the "original one", detailed in the model.

The title therefore gives some information about place and time, and in this defined frame, only the Calvary and the Holy Sepulchre need further consideration, in its "original" state. Therefore, one message that could derived is to go and look at the true and first Holy Sepulchre by way of the Calvary.

The only location of a Calvary and the Holy Sepulchre would seem to be in Jerusalem. Comparing the general geography of Jerusalem with that of the model, and superimposing the Calvary and the Tomb of Arimathea to the Holy Sepulchre, it is clear that none of the details of the model correspond to the real topography of the Holy City. In fact, nothing corresponds between the model and the "true Jerusalem".

We know Saunière did not loose his clarity of mind until the moment he died. So what was the message, the meaning of this model? For in Saunière's time, it was an easy task to acquire a plan of Jerusalem, which

was well-known and mapped. And let us add that any priest could consult and obtain a map of the holy places of Palestine!

Furthermore, one should wonder why Saunière went into such extreme detail to model an environment that has no clear meaning and that would be mocked by any religious person who would come across it. A question that needs to be asked is whether the model therefore corresponds to a geography that is different from that of Jerusalem, a geography that can be found elsewhere, but has the same symbolism, some form of sacred geography, but in its literal sense.

Since 1992, a small number of researchers started to discover and learn interesting comparisons between the model and the area of Rennes-le-Château. The first reflex would be to suppose that the model represents part of an area that the priest knew inside out, leading him to reproduce it easily and true to reality. That the area would therefore be in the vicinity of Rennes-le-Château seems perfectly reasonable.

For many years, I searched to find a viewpoint from which the model could correspond to the real outline of the land, without any success, or even coming close to making an approach. Not the orientation, not a single detail, matched up with the village, Saunière's property, the churchyard, the cemetery, etc.

I decided to order a copy of the model that had by now become too fragile to transport. To create this copy, a negative image had to be created, using supple but resistant latex, which would result in a faithful copy of the original.

It was in studying this negative image that we understood how Saunière had progressed to encode his message in a manner both ingenious and easy to accomplish in his time. For what the priest had done was to take the visible landscape that can be observed by all... which turned out to be the perfect negative of another landscape that represented the real setting of the secret knowledge that he wanted to disguise.

The model, such as it was finally to be, would have been the only sure means of allowing travel through time possible to the ultimate message of Bérenger Saunière, containing the 'crucial' point of its incredible discovery! Once the priest was dead, only a duly elected person, in the possession of the system to "reread", could reconstitute the mystery successfully. The remainder of the multifarious tracks would prove that these were "ways without exits", only there to exhaust the imagination, the perseverance and the tenacity of the researcher, leading to false truths so carefully planned, it seems, by the priest of Rennes-le-Château. And the trap had functioned perfectly. Without the proper key, nothing would

work... and the mystery remained closed... in spite of so many books and publications.

There are therefore various levels on which one can read the model. Together, they form a logical chain. The process is based, like certain other details of the Rennes-le-Château mystery, on the principle of inversion, or mirrors, an idea Saunière might have picked up in the two paintings on display in the church of St Benoit, i.e. the paintings of St Paul and St Peter.

The model in its existing form is the negative of the topography as seen by Saunière. The underlying principle is simply that of the mould. By this method one obtains two types of reversals:

1) in volume: what is hollow becomes an external volume, and depth becomes height.

2) on the surface: what is on top on the right is found, on the negative, below, although still on the right. It does not seem possible that the reversal can take place in a longitudinal direction.

In this system of inversion the readable cartouche on the top right of our model is found, on the negative one, below and still on the right. It will be the same for the indication for North, which is not on the top, but directly at the bottom.

But even with this scenario, the new decor does not correspond with the biblical topography of Palestine, or the vicinity of the Rennes-le-Château region. Then again, this should not come as a surprise. Therefore, the only that remains is to find the true region that served as the basis for the model. Several details allow us to reconstruct the logic as to how the priest tried to attain his goal: in Rennes-le-Château, he learns about the existence of a phenomenal secret. In Arques, he learns or understands that the place of the depot is elsewhere... thanks to certain details he discovers in the community, but also in the Pilat region and the area of Lyons.

When we follow in the footsteps of Saunière's movements, we discover that after these realisations, he often sets off to Perpignan. Or, at least, that is what he tells his entourage. It is also the time when he gets himself regularly invited into the homes of people in the community of Durban-Corbières. Durban-Corbières is now an hour's drive from Rennes-le-Château, if one goes "over the tops", i.e. not via the major roads, but via Arques, and then through the various villages. From Rennes-le-Château to Durban is a straight line.

After lunch with his hosts in Durban, Saunière would excuse himself and go on a walk, always to a place in the village from where one can see a hill that is called "the Mount of Olives", even though not a

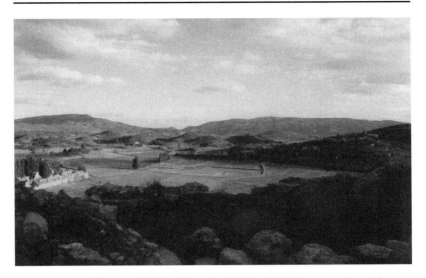

View of the "Mount of Olives" (to the right) of Perillos, seen from the castle of Durban

single olive tree ever grew on it. That Mount forms the only visible part of Perillos that can be seen from Durban, from the castle and the area down its slope, towards the modern cemetery.

It was Saunière's route that we followed closely, without understanding the true reason for his regular trips to this region – but this obscure reference to the Mount of Olives would make some previously not understood items clear.

To understand what it was that the priest was searching for in this region, I visited the area and the historical curiosities, archaeological sites, strange sites, hoping they would shed some insight. These trips, undertaken at the time when the negative was produced, allowed us – quite surprisingly – to discover, in the new area, topographical details that corresponded to the model. The area of the model accurately resembled an area that was a part of the Corbières and the Roussillon. But probably the most surprising aspect of this discovery was not that the area corresponded to the outlines of the model, but also that the inscriptions of the model corresponded to ancient toponyms of that area.

What area are we talking about? The designated sector is situated in the vicinity of Opoul (Pyrénées Orientales) and Durban/Corbières (Aude), the latter being the small town frequented by Saunière. The

101

sector is part of the land of the old village of Perillos, already mentioned. One vital part of our study was to use the cartography in use at the time before the French Revolution of 1789, the time of Bigou, when, as we have seen, he was interested in this region also. These maps are the only ones that show the locations of old oratories, calvaries, old roads, ancient constructions, natural cavities, etc. These details – remarkably one should add – disappeared completely at the start of the 19th Century and no traces, no writings remain concerning these items at present. Nor any other evidence. As an example of what has been lost: as of 1803, a series of seven medieval calvaries, located along the ancient border separating the grounds of Opoul and Perillos, have disappeared without the slightest evidence of their presence remaining. In fact, they have been removed from Mankind's memory; it is only in the Courtade register of 1632 that they can be found.

In this Courtade register, the following features are located on the domains of Perillos:
- a "Montanha Oliveireda", a Mount of Olives, even though there never was a single olive tree located on it, as we mentioned before. But in the 17th Century, there was a calvary located there. Near this hill were the remains of "Moliniera", a mill? One can wonder what one could grind there, as it is extremely isolated, without water, and in a location where there is neither cultivation nor habitation;
- a place called "Monthila testas", "le mont de la tête", the hill of the head. Are we talking about a "skull", as in Golgotha? We have already pointed out the intervention of Simon the Cyrenean during Jesus' ascent of the Calvary. It is at the foot of the "Monthila Testas" that the priest J. Codes, priest of Perillos, held a pilgrimage in 1743 in honour of "Signor Simon"... for the protection of the trees. These two locations are set facing each other, exactly as on the inverted model.

Some other items are also entered in the register. The area is strewn with a multitude of faults and natural pits, as well as dangerous forts. Until at least 1376, there was a small underground oratory dedicated to Saint Elenat. There remain only a few pieces of stone and the cavity is no longer indexed on modern detailed maps. However this cave, rather deep but with no exit, was used for a long time during great droughts, as it was a reserve of surface water for the local shepherds. The burrow N°23 of 1652 gives it the name of 'Cisternele', i.e. small cistern. Is this the cistern mirrored in the "cistern" of the real Jerusalem? The answer is yes.

But this isn't all. The Courtade register also mentions a "terre", a piece of property with a "scépulcture Roïale", a Royal Sepulchre, located in a deep cavity that was used – at least this is what we are led to assume – as a mine during Roman times. The royal notary stipulated that this piece of land, even as the provision of a will, could not be sold, divided into smaller parts, pawned, or even taken legally in a dishonest manner, and this "in the perpetuity of times so that the place is never soiled, violated, emptied, raided or divided". Such an extreme measure was extremely rare and therefore it is worth being highlighted. What was so important about this piece of land that it needed to be singled out... for eternity? And what is "royal" about it? And what "sepulchre" are we talking about? Should it perhaps be "Holy Sepulchre" rather than a "Royal Sepulchre"? And if we are to apply the logic used in the model, does it mean that this "Holy Sepulchre" is that of Jesus? Did Saunière believe that the body of Jesus was entombed in the area of Perillos?

On the plateau of the old castle of Opoul, there is a part of the land that is called "Salveterre" and which can be interpreted as land that is holy, "saved". This "Saved Land" is only some hundred yards from the village of Perillos. This proximity is worth pointing out, in the light of this "untouchable tomb".

Therefore. to summarise, it is clear that the locations indicated on the model can be found within the geographic perimeter of Perillos: "the Hill of the Skull", "the Garden of Olives", "the cistern of St Helena" and the "Oratory of St Simon". From this point of view, it seems logical to admit that the moulding's topography indicates the site of two tombs... one of which is of such an importance that Saunière did not hesitate to compare it with that of Jesus on his model... with the risk of laying himself open to some terrible troubles!

But there still remains the second tomb, that of Joseph of Arimathea. If one studies the history of the lords of Perillos, as well as certain details of their old keep, this Arimathean tomb would be nothing less than the site of the vault containing the remains of this noble but strange family; a family that encountered so many intriguing adventures that they could have, over time, generated similarities between their traditions and legends and the accounts of the Round Table: the castle of the "perilous" threshold (Périllos), the cubic stone of the perron (peron: small pear of the heraldic device of Perillos) found in the ruins of the castle, fights against the evil and darkness (the fight of a Lord of Perillos against a mythical, demonic creature called Babaos) and finally the quest for the Holy Grail whose Holy Cup (part of the arms of the Sabartès) is carried by two bears. Note that the bear was the totem animal of the Roussillon family, of which the most faithful and powerful vassals during the crusade were...

103

the lords of Perillos!

A Great Bear, a clear, solitary depiction of which could be still seen in a cave on the grounds of Perillos, at least as recently as 1776, as noted down by Laborie, the priest of the parish at the time. This priest, obviously impressed with the depiction, reported that the engraving was a remarkable and sizeable ancient curiosity as it surmounts the illustration of the "coupe récipien of Saincte csene of nostre Seygneur Jésus", the recipient cup of Holy Communion of our Lord Jesus.

This Holy Cup, in which was allegedly collected the blood of Christ and the water of its crucifixion, was – according to tradition – taken by Joseph of Arimathea from Palestine to somewhere else. Some state that he crossed Gaule, i.e. France, to arrive in England, Glastonbury in particular. Alas, for the moment that voyage remains completely mythical.

Briefly returning to the tomb of Joseph of Arimathea, it is important to note that he himself would never be able to make use of this sepulchre… which only housed the body of Jesus from Good Friday till Easter Sunday. There is not a single indication Joseph himself was ever buried there.

Moreover, if Joseph finds himself with his Holy Cup travelling around Gaule, would it be reasonable to suppose that shortly before his death, he would make a return to Palestine so that he could be buried in his tomb? Or is it more reasonable to assume that he found a sepulchre closer to the Pyrenean mountains? The latter is the subject of a tradition that is by no means outlandish. But such discussions are outside the scope of the present volume.

In conclusion, it is clear that in reality, the model that Saunière wanted was a strange reproduction, both in topography and toponomy, of the area of Opoul and of Perillos. There is no doubt that the model represented either all or a part of the secret discovered by Saunière, the first hint of which he discovered in Rennes-le-Château, and then confirmed

in the neighbouring village of Arques. But he was not the first to do so, for we also discovered that Bigou, his predecessor as priest of Rennes-le-Château, had visited the same areas of the Corbières and the Roussillon. It is also likely that the secret, or at least parts of it, was shared with his two friends, Henri Boudet and Antoine Gelis, both priests of neighbouring villages. Both of these also visited and stayed in that same area. Evidence for these claims will be produced in a later publication.

In the end, one can wonder whether the model of Saunière was a visual representation of a secret, the true testimony of certain truths now about 2000 years old... and of certain facts that many if not most would like to see forgotten, for good.

Chapter 10
The Other Model

A hoax, trickery, for some a distorted model, a figment of the imagination, a whim, for others merely the madness of Saunière... whatever it is, the model was and is the object of intrigue, questions, irritation... and all of this because of the news of a strange order commissioned by Bérenger Saunière. Nevertheless, I thought that there was no other tangible trace of this puzzling object than that which I had uncovered.

However, there is undeniable proof that other priests were aware of a similar moulding and made use for it for other endeavours. This can be found in a work of a purely religious nature, of which these are the references: "Title: L'Evangile de Jesus, or The Gospel of Jesus. Published by Apostolat des Editions, Paris (France); Editions Paulines, Montreal (Canada) and Institut St Gaetan,Vicence, Italy."

It was the French edition of the Italian book, published by the Institute St Gaetan, that caught my attention. The French edition had been published on October 8, 1979 by P. Faynel, Paris and it stated that it was a "educational presentation by the volunteers of the association MIMEP, reworked and modernised by the care of the Institute St Gaetan, under the direction of one Monseigneur Henri Galbiati", even though his real name, in Italian, is Enrico Galbiati.

The book is based on the four gospels and is therefore indisputably a religious text, presented by priests, under the direction of Monseigneur Enrico Galbiati, a doctor of biblical sciences. It is clear that the contents of this book are supposed to be serious and not a joke. Furthermore, it has been translated in several languages, and is still in circulation in some of them.

It is on page 368 of the French publication that any reader can see, at the very least to my utter surprise, a photograph of the model, presented as an illustration of the biblical places... or at least what we would believe to be such places at first sight.

The preceding two pages of text relate to the process of Jesus, the Calvary and the crucifixion of Jesus. On the following pages, it mentions Jesus, his mother and the disciple John and the death of the Son of God, followed by the entombment of Jesus and his Resurrection. It suggests that the model was used to illustrate certain passages of the bible.

Let us recap. The book was published in 1979 in its French edition,

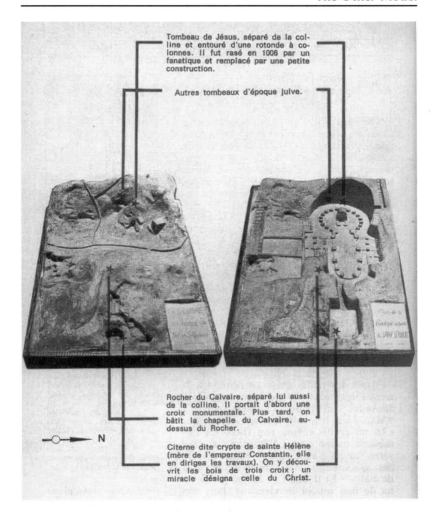

Tombeau de Jésus, séparé de la colline et entouré d'une rotonde à colonnes. Il fut rasé en 1006 par un fanatique et remplacé par une petite construction.

Autres tombeaux d'époque juive.

Rocher du Calvaire, séparé lui aussi de la colline. Il portait d'abord une croix monumentale. Plus tard, on bâtit la chapelle du Calvaire, au-dessus du Rocher.

Citerne dite crypte de sainte Hélène (mère de l'empereur Constantin, elle en dirigea les travaux). On y découvrit les bois de trois croix ; un miracle désigna celle du Christ.

N

whereas I came in possession of the model in 1991. The original title of the Italian book is *Il Vangelo di Gesu*, and was published in 1977 (print date November 1976, published by the Instituto San Gaetano di Vicenza). On the cover title of that edition, it states: "The Gospel of Jesus: new edition: text of four gospels arranged in one single compilation, with 260 diagrams and 120 illustrations, prepared under the direction of Enrico Galbiati."

The model was known about at the time when the Italian edition was produced, during 1976. We also know that a religious congregation claimed to possess that model. Should we assume that several copies

107

were made before the firm created its single, final version in bronze, as requested by Saunière? Is this a second tree hiding a second forest?

The answer is a definite "no", as the model depicted in this book is very similar to Saunière's model, but not identical. It is therefore possible that Saunière came across an existing model, and decided he wanted to have a copy for himself, which he then adapted to suit his own goal and needs.

The model in the book has the following inscription in the cartouche:

Le Calvaire
Au temps de
Notre Seigneur
"The Calvary at the time of Our Lord"

To repeat, the inscription on our model states:

Le Calvaire
Et le St Sepulchre
Etat Primitif
"The Calvary and the Holy Sepulchre – Original State"

This is just one of many differences. On the model in the book there is no mention of a Holy Sepulchre or any "original state". Also note the direction of the writing on the cartouche. It is parallel to the width of the model, whereas in Saunière's model, the direction is parallel to the length of the model.

Also on the photograph, it is clear that the setting near the two calvaries is not identical to that of Saunière's model. And there is not a single piece of written information to be found on the photograph, whereas on Saunière's model, writing and modifications have been added to it by Saunière.

On the photograph, the tomb of Joseph of Arimathea is mentioned as "other Jewish graves". Even though there is clearly only one tomb to be seen, the description nevertheless states there is more than one. Next to the "other Jewish tombs", one can find the "Tomb of Christ". Saunière's model therefore corresponds both to the text and to the actual display. But there are certain details in the relief of the model that do not correspond between the two models in the photograph: around the cistern as well in certain aspects involving volume of land opposite Golgotha. The base of the model in the photograph is also much lower than that of Saunière's. The orientation of the photograph is indicated by the usual method of indicating North, but not on the model itself, rather it is done by the publisher. And this is inverted as opposed to the

ciphered orientation of the model.

To all of this, we need to add that the photograph on page 368 is neither big or very clear, but that all the evidence suggests clearly that the model must predate the 1970s... and is done in a style in keeping with the end of the 19th and the start of the 20th Century. Furthermore, the choice of illustration is peculiar, as it is not accurate nor does it add anything of interest to the object of study, the landscape of Jesus' Passion. We should ask, however, why biblical experts and religious historians could present such a model as an illustration of the settings of where Christianity originated. Whatever the reason for its inclusion, it is clear that a religious group was indeed aware of the model's existence and included it in this publication.

According to the saying, "it never rains but pours", and now we have to note that Gérard de Sède, the original promoter of the mystery, mentioned the existence of this model in his book *L'Or de Rennes* (The Gold of Rennes), even though he does well to mask the fact such artefact exists.

"Faithful disciple of the abbé Boudet, what he [Saunière] has left us [...] is a trail, a model that alludes in detail to places that he explored and to which he had torn off the secret. To accomplish this, he employed a language of metaphors and allegories that mean nothing to a stranger, but can be read by whoever knows the history of Rennes and the toponomy of the region. [...] Saunière, perhaps inspired by others, [...] wanted, and was so successful, that the reading of his cartographic message emerged as a counterpoint of a beam of symbols allowing the initiated visitor to detect the sometimes esoteric work [...]."

Was de Sède merely aware of the existence of the model, or was there more to it? Was he one of those people who knew that Saunière had ordered a model, but at the same time did not know it had survived the passage of time? It seems logical to assume that the same group of "secret researchers" we came across must also have been in contact with Gérard de Sède, the very person who publicised the mystery of the priest. It suggests he was not an "uninformed" person.

Was he interested in trying to locate the model, aware that the model was the key that really would unlock the mystery of Rennes-le-Château? Was all his writing merely an attempt to find out whether the model perhaps did indeed exist, and assuming that his books would attract the attention of many, it might give him an inkling as to the location of the model... and the ability to prise its secret from it? And thus answer the secret of Rennes-le-Château and the mystery of Bérenger Saunière.

Conclusion

Returning to the sacred domains of the bible, there is one area that needs mentioning. However, we need to tread carefully, as the path we are walking on is that of religion.

Jesus, after the Resurrection and hence no longer inside his tomb, first appeared to Mary Magdalene: "So [these women who had found the empty tomb] went out quickly from the tomb with fear and great joy, and ran to bring His disciples word. And as they went to tell His disciples, behold, Jesus met them, saying, 'Rejoice!' So they came and held Him by the feet and worshipped Him. Then Jesus said to them, 'Do not be afraid. Go and tell My brethren to go to Galilee, and there they will see Me.'" (Matthew 28, 8-10)

The model lacks any resemblance to the natural surroundings of Palestine, but instead corresponds to the area of Perillos and Opoul, both in the placenames as well as the lay-out. There is very little literal difference between Galilee, Galicia and "Gaule", the area of France and England, with its links to Joseph of Arimathea. The parallel is there and one cannot let it go unremarked. But does this mean that the "brothers of Jesus" indeed saw their master when they arrived in "Galilee"? In the language of birds, or green language, as used by the French esoterist Grasset d'Orcet, one could say that "Gallilé" can be read as "en galles il est", "in Galle (Gaule) he is". But we should not be that liberal with words.

Perhaps Saunière did indeed acquire evidence about these linguistic and geographical "coincidences", moulding them into a reality. And if so, was he able to foresee the consequences and therefore devised a mode of preserving these elements safely from those intent on obscuring it?

Did Saunière uncover a secret hidden away on the lands owned by the lords of Perillos? What about the old archives, dating to 1640, of the village of Perillos, which are so troubling that the local authorities at first denied their existence? What about the old mines protected by Saint Barbara, a saint associated with miners and lightning, even though the local authorities deny the presence of mines in the area? Or the old caves, no doubt places of initiation and worship, both in ancient and modern times?

The Courtade report of 1632 states that Salveterre, the land of Salvation, the land of the Saviour, which is also the name of an area on top of the

Opoul plateau, was the setting for a tomb containing a "redoubtable secret". The opening of this secret tomb would, the report assures the reader, liberate the Beast of the Apocalypse. It is clear that the author of the report did not mince words when he tried to express the importance of this place! This beast is identified by the number 666 in the bible… and it is another nice coincidence that centuries later, of all the possible postcodes and places, postcode 66600 was given to… Opoul/Perillos. Does God work in mysterious ways, such as coincidences?

Finally, let us conclude by pointing out that certain discoveries have been made on sites close to that identified on the model as the Tomb of Jesus. So far, 27 kg (ca. 60 lb) of money, jewel mountings, bronze objects, pieces of armoury, royal and craftmen's seals, multicoloured marbles, Roman vestiges, pieces of text in Hebrew, etc. have been discovered.

And all of this is no doubt merely the scratching on the surface. Might it have been here that Saunière found his treasure? Is this the reason why he approached goldsmiths in Lyons? Did he ask them to value and possibly date his finds? And did he then sell them off, to finance his expeditions, and possibly certain improvements to his home? Is the treasure of Rennes-le-Château really the treasure of Perillos? Is it a coincidence that the dimensions of the Hautpoul tomb are identical to those of the model? Was this on purpose, as a clever pun devised by the priest to make the connection between Hautpoul and opoul?

Does the material treasure of Perillos accompany an even more important religious treasure, a secret, as indicated by certain "hints" chanced upon along our and his voyage of discovery? Did Saunière use the model as the only possibility left to him to pass his secret on to others?

Epilogue

In his last years, Saunière was said to have aged rapidly. Confined to bed for long stretches of time with heart trouble, he hardly ever left his estate, though he did go on a trip to Lourdes, in 1916. He took to bed several times from November onwards, and though he apparently improved during late December, towards mid January 1917, he had a massive heart attack. It was during this period of his life that he ordered the model to be constructed – it was clear that he himself would never go back to Opoul/Perillos, and he needed a method of transmission; he needed to "show" certain people where his secret was located, and what better mechanism than a three-dimensional model, which could, however, only be read by those "in the know". Hence he used inversions and mirrors, as well as concealing the proper orientation in which to view it. In the end, he died before the model's final completion, and those waiting for the model and his instructions seem to have given in to the belief that all hope had to be abandoned. The secret, it seemed, had died together with the priest.

In the final seconds of his life, before he died on January 22, 1917, Saunière had one final enigmatic message to the world: "John twenty three." Marie came running out of the house, crying "My God! My God." Monsieur le curé is dead. Now everything is finished." There is no hard evidence that either of them ever uttered those words, but they have attained a life of their own in popular mythology surrounding the mystery.

According to one author, Madeleine Blancasall, on January 5, 1917, Saunière signed an order for the creation of a road over the mountains in the direction of Couiza, to drive the car he was planning to buy. He also had plans to install water for all the inhabitants of the village, as well as the creation of a swimming pool for the "baptisms". Only two questions need to be asked: did Saunière have the money for such improvements and, if so, where did he get it from? Did someone perhaps promise him a large sum of money?

According to Emile Saunière, Bérenger Saunière had a heart attack on January 20. Doctor Paul Courrent was called, and he took care of the priest. Courrent apparently even spent the nights there, making sure nothing unfortunate happened to his patient. Saunière also sent for his friend and colleague, Abbé Rivière, the priest of Espéraza, to hear his final confession. His other friends, the priest Gelis, had been murdered some twenty years earlier, and Boudet, the priest of Rennes-les-Bains had

died about two years earlier, in Saunière's own presence. Some claim Rivière was so shocked upon hearing the confession that he himself became ill and incapable of working for several months. Did Saunière pass on to him a "terrible revelation"?

John 23. Some believe that this is a reference to the grandmaster of the Priory of Sion, all of whom were called "John" and entitled "the Navigator". The 23rd grandmaster was Charles Nodier, who died in 1844. Knowing that this list of grandmasters is most likely a recent invention, it seems – to say the least – doubtful this was indeed whom Saunière was referring to.

Saunière was a priest, and would, no doubt, refer to the bible in such a manner. "Matthew 21, 5" refers to the Gospel of Matthew, chapter 21, verse 5. "John twenty three" could therefore be "John 20, 3", i.e. the Gospel of John, chapter 20, verse 3. "Peter therefore went forth, and that other disciple, and came to the sepulchre (tomb)."

Chapter 20 details the Resurrection of Christ. When Mary Magdalene came to the tomb, she found that the stone blocking the entrance to the tomb had rolled away, and the tomb itself was empty. She therefore went in search of Peter and "the other disciple", which is believed to be John the Evangelist. Even though it is debatable whether or not John himself wrote his Gospel, it should be underlined that this was what most people believed then. Both Peter and John the Evangelist observe that the tomb is indeed empty, but return home, leaving Mary Magdalene alone. She sees someone whom she believes is the gardener, but who is actually Jesus, resurrected.

Verse 3 is situated in the middle of the above passage, and shows that until that time, i.e. until verse 3, Mary Magdalene was in a privileged position to know about the "absence" of Jesus from his tomb. It identifies Peter, but also speaks of the "other disciple", John the Evangelist. But the disciple that would be linked to Peter throughout the rest of his life would be Paul, who had changed his name from Saul.

There is, however, also the possible reference to the Apocalypse in the Revelation of St. John the Divine, chapter 20, verse 1-3: "(1) Then I saw an angel coming down from heaven, having the key to the bottomless pit and a great chain in his hand. (2) He laid hold of the dragon, that serpent of old, who is the Devil and Satan, and bound him for a thousand years; (3) and he cast him into the bottomless pit, and shut him up, and set a seal on him, so that he should deceive the nations no more till the thousand years were finished. But after these things he must be released for a little while."

In this verse, the subject is Satan, the serpent or the dragon, imprisoned.

But taken out of context, the subject could be a treasure, or a secret, hidden in an abyss, or a pit, something that would rock the nations of the world if it would ever be discovered. Assuming that if this was the secret he discovered, it was discovered in 1890, and therefore might have been hidden around 890, one thousand years before. Perhaps. There is at present no evidence to suggest that Saunière actually penetrated to the core of the mystery... merely that he was able to locate it.

Perhaps Saunière referred to a chapter 23. But no Gospel has 23 chapters, and the *Apocalypse* comes closest, having 22 chapters. But, at the end of *Revelations*, we find a curious reference: "For I testify to everyone who hears the words of the prophecy of this book: If anyone adds to these things, God will add to him the plagues that are written in this book; and if anyone takes away from the words of the book of this prophecy, God shall take away his part from the Book of Life, from the holy city, and from the things which are written in this book." So perhaps he wanted to express his idea how he wanted to add a 23rd Chapter to the Apocalypse?

What were the seven plagues? Loathsome sores, the Sea turns to blood, the waters turn to blood, men are scorched by the Sun, Darkness and pain, the Euphrates dries up, the Earth is shaken. But perhaps these seven plagues are "merely" a symbolic reference to a journey, like "a hole (or a pit) difficult to find, next to a river where the water has the colour of blood, passing from burning sunshine into shadows, following the course of a dried up river, being careful of earth movements while walking". One can only wonder.

Bibliography

Jean Blum. *Rennes-le-Château – Wisigoths, Cathares, Templiers.* Age du Verseau – Editions du Rocher. 1994.

Antoine Bruzeau and Benoist Rivière. *The Dossier of Rennes-le-Château. Number 1. New insights into Rennes-le-Château.* Translated by Gay Roberts. 1997.

Auguste Callet. *La légende des Gagats.* Republication, Editions du Bastion. 1988.

Louis Challet and Bernard Plessy. *Le Pilat insolite.* Le Hénaff à St-Etienne. 1981.

Jean-Luc Chaumeil. *Le Trésor des Templiers et son royal secret: L'aether.* Guy Trédaniel. 1994.

Jean Marie de la Mure. *Histoire Universelle dy Pays de Forez.* (Volume 1) Jean Poyseul, Lyons. 1674.

Gérard de Sède. *Les Templiers sont parmi nous.* J'AI LU. 1962.

Gérard de Sède. *Le trésor maudit de Rennes-le-Château.* J'AI LU. 1969.

Gérard de Sède. *La race fabuleuse.* J'AI LU. 1973.

Gérard de Sède. *Rennes-le-Château – le dossier, les impostures, les phantasmes, les hypothèses.* Robert Laffont. 1988.

André Douzet. *Eléments du passé de Sainte-Croix-en-Jarez chartreuse, pour servir à son histoire.* 1994.

Charles Lenthèric. *Les villes mortes du golfe du Lion.* Republication of Jean de Bonnot. 1989.

Franck Marie. *Rennes-le-Château – étude critique.* Vérities Anciennes. 1978.

Jean Markale. *Rennes-le-Château et l'énigme de l'or maudit.* Pygmalion/Gérard Watelet. 1989.

Charles Porée. *L'abbaye de Vézelay.* Henri Laurens. Around 1910.

Jean Robin. *Rennes-le-Château – la colline envoutée.* Guy Trédaniel. 1992.

Tchou. *Guide de la Provence mystérieuse.* 1979.

Jean-Michel Thibaux. *Les tentations de l'abbé Saunière.* Olivier Orban. 1986.

Jean-Michel Thibaux. *L'or du diable.* Olivier Orban. 1987.

DARWIN'S MISTAKE
Dr Hans Zillmer

Yes, there were cataclysms (among them The Flood) in the course of history, but no, there was no evolution. The Earth's crust is relatively young and no more than a few thousand years ago; its poles were free of ice.
Published in nine languages, this international bestseller puts the latest discoveries and new evidence against Darwin's Theory of Evolution. The author, who owes his insights and expertise to numerous excavations he participated in, describes recent findings that – in line with suppressed results of scientific research – prove what seems unthinkable to us today: Darwin was wrong.

*120 Pages. Paperback. Euro 25,90 * GBP 14.99 * USD $ 19.95. Code: DMIS*

CROP CIRCLES, GODS AND THEIR SECRETS
Robert J. Boerman

For more than 20 years, all over the world, mankind has been treated to thousands of crop circle formations, and until now, nobody has been able to explain this phenomenon. In this book, besides a scientific and historical section, you can read how the author links two separate crop circles. They contain an old Hebrew inscription and the so-called Double Helix, revealing the name of the 'maker', his message, important facts and the summary of human history. Once he had achieved this, he was able to begin cracking the crop circle code.

*159 Pages. Paperback. Euro 15,90 * GBP 9.99 * USD $ 14.00. Code: CCGS*

Available from the publishers

THE TEMPLARS' LEGACY IN MON-TREAL, THE NEW JERUSALEM

Francine Bernier

Montréal, Canada. Designed in the 17th Century as the New Jerusalem of the Christian world, the island of Montreal became the new headquarters of a group of mystics that wanted to live as the flawless Primitive Church of Jesus. But why could they not do that in the Old World? The people behind the scene in turning this dream into reality were the Société de Notre-Dame, half of whose members were in the elusive Compagnie du Saint-Sacrement. Like their Templar predecessors, they worked for humanity and aimed to establish an ideal social Christian order. Montréal's destiny was to become the refuge of the most virtuous men and women who expected the return of a divine king-priest; a story connected with the mystery of Rennes-le-Château, and the revival of a heterodox group whose marks, and those of the French masonic Compagnons, are still visible today, both in the old Montréal city... and underneath.

*360 pages. Paperback. GBP 14.99 * USD $21.95 * Euro 25.00. code: TLIM*

NOSTRADAMUS AND THE LOST TEMPLAR LEGACY

Rudy Cambier

Nostradamus' Prophecies were *not* written in ca. 1550 by the French "visionary" Michel de Nostradame. Instead, they were composed between 1323 and 1328 by a Cistercian monk, Yves de Lessines, prior of the Cistercian abbey of Cambron, on the border between France and Belgium. They reveal the location of a Templar treasure. Nostradamus' "prophecies" has shown that the language of those verses does not belong in the 16th Century, nor in Nostradamus' region. The language spoken in the verses belongs to the medieval times of the 14th Century, and the Belgian borders, not the French Provence in the 16th Century. " The location identified in the documents has since been shown to indeed contain what Yves de Lessines said they would contain: barrels with gold, silver and documents.

*192 pages. Paperback. USD $ 17,95 * GBP 11,99 * Euro 22.90. code: NLTL*